MW01007813

MODEL CITIZEN

The Autobiography of Jeremy Meeks

JEREMY MEEKS

Title: Model Citizen: The Autobiography of Jeremy Meeks
Author: Jeremy Meeks
Subtitle: The Autobiography of Jeremy Meeks

Copyright © 2024 by Kingston Imperial, LLC

Modeling Photography copyright ©2023 by Jim Jordan and Kingston Imperial, LLC.

Printed in China

Disclaimer: This book is a memoir. It reflects the author's present recollections of experiences over time. Some names and characteristics have been changed, some events have been compressed, and some dialogue has been recreated. Though the author's words are not written to represent an exact transcript of events, in all instances, the essence of dialogue is accurate.

Publisher's Note:
Kingston Imperial is committed to publishing works of quality and integrity. In that spirit, we are proud to offer this book to our readers; however, the story, the experiences, and the words are the author's alone. The author in no way represents Kingston Imperial, and the views expressed in this memoir are solely those of the author.

All Rights Reserved, including the rights to reproduce this book or portions thereof in any form whatsoever. For information, please contact Kingston Imperial, LLC, Rights Department, at info@kingstonimperial.com.

First Edition:

Book and Jacket Design: Laura Dapito
Cataloging in Publication data is on file with the Library of Congress
Hard Cover: ISBN 9781954220669
Ebook: ISBN 9781954220676

PREFACE

When you're arrested, you're always photographed. Then, without your consent, these images are posted to the internet, creating permanent personas that people can never shake in the public eye. It's done on purpose to shame the person and to send a message to others.

If you're reading this book, it's likely because you recognized my image on the cover. In 2014, my face went viral from a mug shot that was released on the internet through the Stockton Police Department's Facebook page. Ninety-six thousand people have liked the post in which the department announced that I was arrested on felony weapons charges at thirty years old. The post has twenty-four thousand comments and has been shared eleven thousand times.

Beverly Hills, California, May 22, 2022
I don't remember dreaming as a child. It just wasn't something I did. I didn't dream about being a fireman, or a policeman, or an NBA player. When I saw an expensive car whiz past our station wagon, I never pictured myself behind the wheel.

I didn't have room for fantasies. That was a privilege for others.

There was a time in my life when I was forced to steal so that my stomach wasn't empty every day. If I wanted a sandwich, figuring out how to get one was more useful than pining over it. So daydreaming wasn't high on my agenda.

Years later, on an aggressively sunny California day, I was surrounded by dreamers.

The room was filled with members of Black high society. People who had been born to dream and bred in a way that placed their dreams within reach. I looked around at the elite from my perch at the head of the room.

Members of Alpha Phi Alpha and Delta Sigma Theta mixed with Howard University deans over tables full of catered appetizers while representatives from the California Bar Association chatted with news anchors and real estate brokers. People draped in Gucci and Chanel threw up Black fists in front of the step-and-repeat banners.

It was a room I never would have been invited into in a prior life.

Dr. Lance Stevens had asked me to attend the second annual Breathe Brunch hosted by the George Floyd Foundation. As someone who had encountered police brutality and nearly died from it on multiple occasions, I was eager to bring genuine life experience to the cause. My newfound fame was helpful for that.

The emcee asked the room what they dreamed of as children before inviting myself and another notable attendee to participate in the conversation.

As I sat uncomfortably on the stage, it dawned on me that the first time I ever dared to dream was when I was sitting inside a federal prison cell.

CHAPTER 1: TAKING FLIGHT IN TACOMA

Tacoma, Washington, 1988

My mom, Kathy Angier, was born in 1954 and grew up in Redwood City, California, which is in the heart of Silicon Valley and home to the famous Fox Theater.

My mom was always the rebellious one of her siblings. She was wild and impulsive, causing her to constantly clash with her parents' strict rules. My grandma enforced a rigid set of guidelines. What my grandma said went in their household, and my grandpa always followed her lead.

My mom spent much of her childhood trying to escape the confines of her parents' structure.

The first time my mom ran away from home, she was only thirteen. She ended up in juvenile hall, and that was when she found out that the man she knew as her birth father was not actually her birth father. When she was booked, she was told her birth certificate had a different last name. Her mother had lied to her about her past for years. She started doing drugs, and her negative self-esteem had her gravitating toward men who were not good to her. She ended up in a lot of abusive relationships

throughout her life. She got pregnant with my sister Leanna when she was seventeen. She fell in love with an older man, and he promised her the world. One day Leanna's dad said he was going to work and never came back. Although he did manage to clean out their bank accounts before disappearing. She had no idea what to do or how to take care of a child on her own. She was still just a child herself, and he left her pregnant and alone with nothing, except the blessing of my oldest sister, Leanna.

She ended up moving to Tacoma, Washington, which was on the west side of the Evergreen State. A few years later, she met a guy named Eldon and had my sister Carmela. Again, she thought she had found the one. The one who was going to save her from herself and her pain. They were together for a while, but after an emotional breakup, they eventually parted ways. It was after that when she fell for my father, Ray Emerson Meeks. Both my mom and my dad did a lot of different kinds of drugs and were heavily addicted to heroin. He was another one who promised her the world but then shattered it. They would drag each other in and out of methadone clinics, trying to treat the disease they were fighting. For years, it was a never-ending battle.

Ray was physically and mentally abusive. He was filled with an uncontrollable anger, and my mom felt powerless to stop him. At one point she had even gone back to Eldon to try to escape

him. My dad saw them together, driving down the street in Eldon's van, and he started shooting at them while my sister Carmela was lying in the back seat. He made the excuse that he didn't see Carmela, like that somehow made it better. The van crashed and flipped numerous times. It was surprising that none of them were severely injured. That's what he was—chaos. He brought a whirlwind of chaos everywhere he went. Even after all that, my dad still managed to get my mother back. When you're an addict and also living in a constant state of trauma, everything becomes cloudy, and she ended up stuck in a very unhealthy cycle with my dad.

They had my older brother, Emery, in the winter of 1981, and three years later they had me. I was born on February 7, 1984, in Tacoma, Washington. My dad continued to get more and more violent and to expose my mom to more and more horrific things. He subjected her to the worst experiences imaginable, and I thank God she survived. She's been through a lot, probably more than I'll ever know, but certain things aren't my story to tell.

When I was a few months old, she left my dad and moved us into an apartment. My dad didn't know where she had taken us, and he lost it. He searched for her around the entire city, hitting all the spots she would go to and harassing all the people she knew. He went to her best friend's house and demanded she tell him where

we were. When she refused, he tortured her for five hours before taking her life. When my mom got the phone call from a neighbor, she burst into tears. Her friend gave up her life to protect my mom, but in the end he still found us. My sister Leanna was watching us kids, and when my mom came home, she saw my dad standing in front of my bedroom window whispering to me. She started yelling at him, and he brutally assaulted her. He took her to a motel, where he continued his abuse.

A few days later, the police found him and charged him with murder. Once he was arrested, I never saw or spoke to my father until I was thirty years old and during which time he tried to hustle me for five grand. Imagine you get locked up for murder, you have two beautiful baby boys, you spend thirty-three years in prison, you don't see them grow up at all, you're just daydreaming about doing father-son stuff and playing with your grandkids, and you revert back to the same person you were when you first went away. That's sad. When I was young, I would overhear my mom and my sisters whispering about my dad. They didn't want me to know, but I would peek around the corner and quietly listen because I could tell that they were keeping something from me. It was very hard to hear the terrible things he had done. To know what he did to that woman as well as the endless list of horrible things he did to my mother. It was a struggle. I was lucky

I was just a baby when he got locked up.

It was also a struggle to know that man's DNA ran through me. I felt so many different ways. I hated him, but I also wanted to know who he was and to try to understand him. A big part of me felt like I was somehow destined to end up like him and live a life behind bars. That belief became my self-fulfilling prophecy.

Sometimes when my mom looked at my brother and me, I knew she could see my father in us, but she never compared us to him. She wasn't an overly affectionate person, but she showed us her love in the best ways she knew how.

Eventually, my mom kicked the heroin habit for good. It was a huge accomplishment for her. Heroin is one of the hardest drugs for people to stop using, and her addiction was locked into that spiral with my dad. It was a transformative moment for mom when he went to jail. She experienced all manner of healing—emotional, physical, and spiritual—but the first step was to go to a methadone clinic. She suffered from depression and carried the weight of the world on her shoulders. I could see it in her eyes when she'd get these blank stares, and I could feel this overwhelming sadness coming from her. But my memory of my mom, for most of my life, is one of a survivor. A clean survivor. She got a job with an insurance company, and she worked a lot to keep a roof over our heads and food on the table, but it was hard for her.

So, at a very young age, my sister Leanna stepped up to the plate and took on the role of caretaker. She really helped my mom out and took such amazing care of all of us kids. She came into this world with a heart of gold.

I was always keeping my mom and Leanna on their toes. When I was little, I climbed to the very top of a motor home, dragging my tricycle behind me, and rode off the roof because I was convinced with every fiber of my being that I could fly. I successfully stuck the landing with my face, and it took hours to pull out all the rocks. Halloween was a couple of days later, and I remember feeling really insecure about the wounds all over my cheek, so my mom's boyfriend at the time, Hutch, grabbed some gauze from the hospital he worked at and wrapped me up like a mummy. I will never forget that.

By the time I was seven years old, I was stealing my mom's Zimas, smoking cigarettes, and filching the leftover roaches from her ashtray. I came into this life wanting to try it all. My friend and I used to go to this creepy abandoned warehouse near where we lived, and we would throw rocks at the windows. I don't know what it was about breaking glass, but it gave me this exhilarating feeling. It was like I could take everything I was experiencing, all that pain and anxiety, and channel it into that rock. When I heard the glass break, it felt like I could finally breathe again, and my

whole body would relax. I couldn't really explain why it made me feel so good, but breaking windows was definitely one of my favorite things.

My love of broken windows got me into trouble a few times. One day I explored a construction site where these really nice houses were being built. There was this brand-new, beautiful house that was covered in large picturesque windows, and I broke every single one in that house. Someone nearby heard me smashing the glass, and they called the cops. When the police arrived, they called my mom. The look on her face when she got there was ten times more painful than riding off that rooftop.

It was my first real experience of remorse.

I remember it like yesterday. My chest heaving with a burden heavier than any I'd ever known. My heart sinking, and in my mom's eyes, the sheer despair as the police and the homeowner told her what the damage would cost, because there was no way she could cover it, and it was on me. She was broken and powerless, hopeless, cornered by financial precarity and impending eviction, and it was all down to my thoughtless actions.

That look, the sting of it, was more severe than any physical wound I'd ever endured.

But that was me. I took everything to the extreme, and I went

from zero to one hundred in a split second. Sometimes I would do things and not even know why I was doing them. I remember having this GI Joe figure that I loved so much. One day I found a lighter and lit the damn thing on fire just to see it burn. I watched the plastic drip to the floor, knowing that it was my favorite toy and that I should stop, but I couldn't help myself. I was fascinated by that melting plastic.

I also inherited my mom's wild, impulsive nature, and I frequently felt this buildup of anger inside me. As I got older, I started to understand these behaviors better. The school sent me to a doctor, and I was diagnosed with a learning disability, attention deficit hyperactivity disorder (ADHD), and I'd go through times of anxiety and depression. I knew that these things weren't going to suddenly disappear, and I've spent a lot of time learning how to cope and adapt.

When I was in third grade, we moved to Rhode Island to live with my grandparents. I got along with them pretty well.

I loved my grandma, Donna Silva. She passed away at the beginning of 2023. I was still a pain in her ass, and she was a lot stricter than my grandpa. Put it this way—she had no problem hitting me upside the head when I was acting up. She was a tough woman and one I did not want to cross, ever. However, she loved us kids and always wanted the best for us.

We stayed with my grandparents for a little while until my mom got us a new place. The school I went to in Rhode Island was different from any school I had ever been to. My grandparents had previously enrolled us in a Christian school, but the public school we attended after was the worst.

I had a really hard time there. Kids today wear their neurodiversity with pride, and it's great. They're open with their peers about their disorders, and they trade information about their experiences and therapy. Parents have an internet full of information and access to support groups. Things were not like that in the 1990s. People were not as educated about ADHD or about children born addicted.

The school staff members were not understanding or compassionate. I felt like something was wrong with me and that everything I did was a problem. I was constantly getting yelled at for this or that. They treated me like the way I showed up in the world was unacceptable. The adults charged with my education did not have an interest in understanding the storm that was happening inside my brain. All they wanted to do was squash it. It made me angry, and the angrier I got, the more I acted out. The kids weren't much better. They mocked and made fun of me all the time.

Eventually, I was prescribed Ritalin, and within a couple of

months, I had turned into a full-blown zombie. When it was explained to the school and to the doctors that I wasn't in a good place and seemed like a completely different person, the doctor's response was to up the dosage. You have this little kid here, barely functional, and you want to give him more? But that's what they did back then. They didn't want to fix it; they wanted to suppress it. They wanted to take the easy way through it instead of trying to figure out what was actually going on inside my mind, inside my home, and inside my body.

I spent the majority of my third grade year in a fog. I could barely function in class, and I was constantly falling asleep. They continued upping the medication, and I ended up failing the year and having to repeat it.

My mom didn't know what to do, and because she was constantly fighting her own misunderstood chemical imbalances at that point in her life, she wasn't able to help me in the way that I needed.

My sister Leanna saw how hard things were for my mom, and she knew that my mom wasn't in a position to be able to care for my brother and me. She realized that my mom needed to learn how to care for, love, and value herself first. As soon as Leanna turned eighteen, she immediately enlisted in the air force, and once basic training was over, she made the announcement that

she would be legally adopting Emery and me. Carmela was already grown by this time, with a child of her own, but Emery and I were just preteens.

My mom was furious. She fought tooth and nail to stop that from happening. She didn't want to give us up, but she didn't know how to fix it. She was mad at my sister for a long time. It wasn't until later in life that she realized that Leanna didn't do that to punish her. She did it not only to help my brother and me but also to allow my mom the space she needed to be able to work on her own healing.

It was hard to leave my mom. She's my mom, no matter what she was going through. I wasn't sure how to feel about moving away to live with Leanna. I knew my mom was so sad, and I didn't want to hurt her. It left me really confused. When I look back on it now, had my sister not done that, had she decided to just carry on with her own life and allowed herself her youth, my life would have turned out completely different.

CHAPTER 2:
RHODE ISLAND BLUES
AND VERY TINY WHITES

West Warwick, Rhode Island, 1994

My mother was a runner. When things got too hard for her, she took off. When I was still in the third grade, she dragged us back home to her parents' to take some of the pressure off herself.

She drove us across the country in her old-school station wagon. I saw the whole nation through the back of that car window.

I got along with them pretty well. My grandpa, Raymond, had more patience with my impulsive side, and he always found a way to instill in us little life lessons. He was always very good to me. He used to pay us to dig trenches on his property. It wasn't because he needed trenches but because he wanted to teach us about working and earning money. He wanted us to know the value of a hard day's work and to appreciate the fact that our two hands made that money. I've always valued the little seeds of wisdom that he would place on me.

After the attention deficit hyperactivity disorder (ADHD) diagnosis my mother, like a lot of parents in the nineties, tried to advocate for me, but she didn't know the right questions to ask

the doctors and administrators, so more Ritalin went in and more of my personality was quashed. The research and information was not as readily available as it is now. She was on her own, and it was hard. And you know what? It may sound strange, given the impact those days had on my life, but I don't remember the names of the doctor, the kids, or the school. It's like there's a black hole where they're supposed to be.

I don't believe in generational curses, but I do know that genetics are real.

Children who are born to addicts are likely to display the lack of focus and behavioral problems that I showed in the classroom. They can have diminished cognitive abilities and trouble weighing the consequences of their actions. There are studies into neonatal abstinence syndrome (including the Ottawa Prenatal Prospective Study and the adult consequences of prenatal drug exposure published in the *Internal Medicine Journal*[1]) that claim they have a high rate of ADHD diagnoses, but no one in power was monitoring my family situation close enough to make this connection and try to do something about it.

I wasn't that lucky.

There was no devoted guidance counselor or social worker

1 Ju Lee Oei, "Adult Consequences of Prenatal Drug Exposure," *Internal Medicine Journal* 48, no. 1 (2018): 25–31, https://doi.org/10.1111/imj.13658.

with a heart of gold to see the good inside me and go to bat for me. No one at school or at home was asking questions about why I was acting out. The information was out there, available to anyone who was looking to connect the dots, but the reality of life is that more often than not, good people are too busy scraping together mortgage payments and figuring out their own problems to go on an epic quest for the truth.

My family tried. Each person had their own unique way of showing me that they wanted me to succeed.

My grandmother used to pull me aside to try to correct my behavior the best way she knew how. But we didn't really have two-way conversations. It was more like a monologue where she spoke using her belt.

Like I said, My grandfather was more patient. Instead of banging on me, my grandfather did his best to instill lessons about hard work and a genuine work ethic. "This situation right here isn't fair. And I'm with you," he would tell me on the afternoons we spent together. He wanted me to look beyond what I was exposed to or going through and to see the way out on the other side.

But those life lessons of his didn't help fix what I was going through back then.

Later we learned that I had another learning disability, but at

the time no interventions were taken other than these thick chalky white pills I had to make my way to the nurse's office to take, whether I wanted to or not, while everyone else was still in class. I had no choice in the matter; no one ever asked how any of this made me feel.

My mother's taste in men did not improve with the addition of a new forwarding address. She hooked up with a guy named Jack shortly after we arrived. Jack was a real piece of shit, and none of us liked or trusted him. He was really smarmy. He used to slap us around during the two years that he lived with us.

One day he showed up out of the blue and invited me to hang out with him one-on-one.

"Jeremy, come on. Let's go get some pizza."

The invitation seemed random to me. My mother was somewhere trying to rub two nickels together so that we could survive through the next month, so she wasn't around to join us.

Where's this coming from? I thought to myself. He was waiting for me in the biggest pickup truck I have ever seen in my life. I stopped before getting in.

"I'll be right back. Just let me go get Emery right quick."

"No, Emery ain't going. It's just me and you. He's not getting any pizza." Today I know that he and my brother were beefing at

the time. Being older, my brother was bucking against him and displaying his mistrust of him openly.

I thought, *Wow, my brother's not going. Okay, then I'm not gonna go eat pizza.* My sense of loyalty was too solid to be a part of trying to rub my big brother's face in some shit. Jack was upset that I was refusing to participate in his petty bullshit.

"Get in the truck."

"No, I'm not gonna get in the truck."

His face twisted, and he grabbed me by the neck and slapped the shit out of me before throwing me into the vehicle. My small body bounced against the door of the pickup. As fast as he threw me in, I scurried just as fast to the other side. I was already pulling the door latch and was out of the truck before he could get inside.

He looked around and saw I was gone. I ran all the way up the hill to my sister and brother. I don't know what Jack was planning other than leaving my brother out, but it didn't matter. I knew I would be safe with Emery and Carmela. They were my home.

My sister Leanna had practically raised us her whole life, and now she was going to take the steps to make her guardianship official. She was concerned that we would slip through the

cracks under our mother's care.

My mom was furious. She fought tooth and nail to stop it from happening. She didn't want to give us up, but she didn't know how to fix it. She was mad at my sister for a long time. It wasn't until later in life that she realized that Leanna didn't do that to punish her. She did it not only to help my brother and me but also to allow my mom the space she needed to be able to work on her own healing.

It was hard to leave my mom. She's my mom, no matter what she was going through. I wasn't sure how to feel about moving away to live with Leanna. I knew my mom was so sad, and I didn't want to hurt her. It left me really confused. When I look back on it now, had my sister not done that, had she decided to just carry on with her own life and allowed herself her youth, my life would have turned out completely different.

My sister did more than file for temporary guardianship. She legally adopted my brother and me. At twenty years old, she stepped up to become a parent to a thirteen-year-old and a ten-year-old.

My current birth certificate still has her name in the space where my mother's name used to be. It's a sore spot with my mother, but I know her. I know that she did the best she could

and that she gave all she had to the situation, but she just had a tough time like many parents do.

It's a feeling I'm familiar with.

CHAPTER 3:
CLASS DISMISSED

Medical Lake, Washington

Leanna moved us back to Washington, where she was stationed at Fairchild Air Force Base just outside of Spokane.

The town we lived in was called Medical Lake. Its population was only three thousand people. It had a quaint small-town atmosphere. Medical Lake was the type of place where everybody knew everyone and there were no secrets. People felt safe there. No one locked their doors. There were no concerns about intruders or predators. People allowed their children to roam the sidewalks freely without worry.

I still can't believe how incredible my sister is and what she sacrificed to take care of us. Many others, including myself, respond to trauma by leaning into the chaos of their lives and accepting it as their fate. They operate as if they don't have choices. Not Leanna. She fought against it—hard. She didn't do drugs, and she didn't run away from her problems. Escaping reality wasn't something she was interested in. She embraced it and brought tenacity and positivity to every situation. Leanna worked so hard to provide a good life for us. Her family was and is her top priority. When other people her age were out doing

shots and dancing on tables, she was either picking up extra shifts or trying to help us with our homework. She wanted what was best for us, and she showed us that every day.

It was the first time in my life that I had stability.

I was apprehensive about moving at first, but when I got there, I fell completely in love with the place. The lake the town was named after was picturesque. I loved that no matter what direction you were coming from in town, you ended up at the lake. It was a beautiful, peaceful place full of wholesome activities for the families who lived there.

One of my favorite times of year at Medical Lake was the annual fisherman's breakfast. That event marked the first opening date of the fishing season. The town would put on this big breakfast buffet that opened at the stroke of midnight. They held it in the local firehouse, and they had every kind of breakfast food you could think of on display. My friends and I would gather all our fishing supplies and head to the beach to camp out at the lake the night before. Someone always managed to get their hands on some MD 20/20, and we would stay up all night drinking around the fire. At midnight, when the doors to the firehouse would swing open, we were right there waiting to dig into the platters of delicious food. We would stuff ourselves with this amazing and massive breakfast and then go back to our campsite and fish all day.

I love fishing. It's on the top of my list of things I love to do. There's something so relaxing about being out on the water with nothing but some music and a fishing pole.

The air force base and a nearby psychiatric hospital, Eastern State, which was built in the 1800s, were the major attractions in the tiny town. Unless you worked at one of the two, there wasn't much to do besides get in trouble.

Practices at the hospital were common knowledge because of how small the town was. They used to do experimental tests on monkeys, and all the kids talked about how it was rumored that the place was haunted by the souls that had undergone treatment there. Generations of families had worked at the hospital, and you could just imagine that decades' worth of stories from different departments were passed down. Everyone knew someone who had witnessed something supernatural occurring within the walls of that facility over the years.

My eldest sister is a pretty straitlaced person. While I leaned into the chaos of our childhood, accepting it as our fate, she fought against it. She was still very young, but while her former classmates were all figuring themselves out at raves, she was signing up for extra duties and pleading with us to do our homework.

She was really responsible, and for the first time, I had things

like money to order pizza after school and extra socks for gym class. Back in the day, when I first started school, we didn't have the money for new clothes or shoes. I used to get so mad when mean kids would make fun of my clothes or point and laugh at the torn soles of my shoes flapping like a talking puppet as I walked down the hallway. But when we moved in with Leanna, she worked extremely hard to make sure we had nice clothes and good shoes. We were never without. She wanted us to feel good about ourselves and the way we showed up in the world.

My brother and I had a lot more opportunities under her roof. We both shined when it came to athletics. I was finally off the Ritalin and feeling alive and responsive again. Even though Medical Lake was a small community, the military base brought a lot of diversity to the area. I made friends with kids from all walks of life, and many of them became like family to me. I have really good memories from that time. I felt safe and cared for.

When we weren't in school, we would ride our bikes to the nearby sandpits and go fishing at the lake. There were a lot of camping trips on the weekends and bonfires thrown in the woods. I still got myself into trouble at times, but I was a kid finding my way and having fun.

One time my friend Levi had just gotten a brand-new bike and came over to my house to show it to me. It was getting pretty

late and we had school the next morning, so Leanna told me that I couldn't go out and ride the bike with Levi. She wanted to make sure I had structure so that I could excel in school and sports.

I had just gotten out of the shower when I saw that Leanna was headed down the street to the local grocery store to grab some milk for our breakfast in the morning. I sat on the couch and acted as though I was just going to head to bed, but in my mind I had a plan. I waited anxiously for her to turn the corner and then immediately jumped up to see if Levi was still outside so that I could check out his new wheels.

Since I had just gotten out of the shower, I was only in my boxers, so I grabbed a throw blanket off the back of the couch and wrapped it around me, then ran outside. I was so excited when I saw that Levi was still there. I hopped on that bike and started going as fast as I could down the street. My joyride didn't last very long. The blanket I had wrapped around me got stuck in the spokes, and the bike instantly stopped. I flew over the front of the handlebars and hit the ground face-first.

I slammed into the road and skidded across the gravel. I barely had a second to think about how I ended up on the ground before I realized I was busted. Next thing I knew, Leanna was coming around the corner and pulling up to the house. She was pissed! I had so many rocks in my face that she had to take me to

the base hospital to have them cleaned out and patched up.

I remember the glare of the hospital lights as she looked at me with a furrowed brow and said, "Now, Jeremy, that is what we call karma."

When I got a little bit older, I moved beyond bikes and started playing with different toys. I had a tendency to take my sister's Subaru without permission. I would sit in my bedroom, quiet as a mouse, and wait for her to fall asleep. Then, as soon as I was sure she wouldn't wake up, I would tiptoe through the house and ever so carefully grab her keys out of her purse. I didn't want her to hear me start the car, so I would put it in neutral and push it out of the driveway first, then I would hop in and take off.

I felt so cool driving that car. You couldn't tell me that I wasn't grown-up. I would pick up some of my friends, and we would go joyriding down all the back roads in Medical Lake. Her car was a manual, and that's how most of my friends and I learned to drive a stick. We almost got caught a few times stalling out in front of people's driveways. They would come out on their porches at two in the morning to stare us down. We would peel out as fast as we could to get away from them. All you could smell was rubber from the clutch burning up as we made our getaway. My sister would wake up in the morning and wonder where the hell all her gas had gone.

Leanna put up with a lot. Not only from us but also from the outside world. She had to deal with the judgments of others everywhere she went with the two of us in tow. She didn't care what anybody thought about what color we were, though. She loved us. We were her brothers. There was a time, shortly after we first returned to Washington, when she drove us to Coeur d' Alene, Idaho, so that we could spend the day at the lake and go swimming. She packed us lunches, and we hung out there all day. On the way home, we stopped at Red Lobster for dinner.

As soon as we arrived, we all noticed the stares directed at us. We felt the racism, discrimination, and judgment being shot at us like daggers. It was clear that we weren't welcome in their community. As more customers came in behind our family, the hostess started seating them before us. This went on for a very long time until Leanna marched to the front and asked to speak with a manager. With a smug demeanor, they finally agreed to seat us, but Leanna had had enough of their hatefulness. She gave them a piece of her mind, then we left the restaurant and went to McDonald's. Leanna has always been tough, even before she joined the military, and I was so proud of her for sticking up for all of us. She was definitely our soldier.

I was pretty good at most of the sports I tried, but I did best at

basketball. Eventually, I qualified for an Amateur Athletic Union team. I was traveling and doing tournaments throughout middle school. My sister sacrificed to be able to financially support our endeavors and to expose us to new experiences. She donated her time to supporting me as well. She was always there to take me to my basketball tournaments. Every summer I would sign up for Spokane's basketball tournament called Hoopfest. It's the biggest three-on-three tournament in the country, and it brings out a ton of spectators annually.

When we lived there, I learned how to ski for the first time. I had been suspended from school, and my sister was going with her friends and didn't want to leave me at the house by myself because I would end up getting in trouble. She tried everything she could with me.

I was still getting into scuffles here and there, but it was the most structure I'd ever had.

My sister made sure that I didn't continue with those zombie meds. I was more open and able to connect with my teammates and my coaches.

Emery was balling out on the field at the local high school. He was determined to get the scouts to pay attention, and he put in as much effort as he could at practice and in the weight room.

We were each doing okay when we found out my sister was

getting transferred to California.

Fairfield, California, 1998

Leanna had to report to Travis Air Force Base in Fairfield, California. She didn't choose the assignment, but she had to take it. She was very committed to the military. It was her sole source of income and the basis for the future she was creating for herself. Leanna felt terrible that we had to leave, but she served our country like she served her family. She gave it everything she had. As the adult in our lives, she had to do the most responsible thing, and reporting for duty in California was it. I knew there was always the possibility of moving because she was in the military, and lots of families around us were forced to relocate on short notice as well, but when it finally happened to us, I was upset.

My whole world came crashing down with the news. By this time I was extremely close to the group of friends I had made, and I didn't want to leave. I was finally at a place that felt like a home, and now we had to leave and start over.

When we got word about the move, my brother was close to graduating high school and was doing really well at football. He was a natural and moved across the field like an unstoppable force.

Emery ended up staying in Washington with family friends so that he could finish out the football season and have a chance to go to college. He had caught the attention of recruiters from Eastern Washington University, so he decided to stay in the area. No one in my family had ever gone to college before, so I was really proud of him. I understood why he wanted to stay, but it didn't hurt any less when I had to tell Emery goodbye.

I was devastated. Being away from him broke my heart.

My brother and I had promised that we would never spilt up or leave each other. We were the closest in age, and he really was my best friend. I was furious that I had just gotten comfortable and was getting used to being back in Washington, and now I was heading to unfamiliar territory.

I was mad at Leanna. I was mad at my mother. I was mad at my brother. I was mad at everyone, and the person I took it out on was myself.

Now that I'm nearing my forties, I realize that I had every opportunity to pretty much do whatever I wanted when I lived with Leanna.

I could never blame my choice to join a gang entirely on my childhood or on my family background. Everything I did was a conscious decision. I've met people who had it way worse than me. I know people who didn't have anything to go home to, or

what they were going home to was worse than what I was, and some of them still managed to become doctors and lawyers and to get their PhDs.

Instead of being restricted by their circumstances, they were motivated by them. I wasn't there yet as a teenager or as a young adult. My coming-of-age moment arrived later in life.

It doesn't matter what kind of life I was given by my sister sacrificing her youth to care for us. I was still going to make horrible decisions and learn everything the hard way. I had to bump my head numerous times on the same obstacles my father did before I learned that my biggest issue wasn't a military reassignment, an absent parent, or a tiny white pill being forced down my throat.

It was myself.

I accepted that my response to the trauma I experienced was the only truth possible. Even when offered alternate paths, I made choices based on the truth I recognized, and it wasn't until I rejected that truth that I could see another way of life.

When we got to Fairfield, California, I was enrolled at the local middle school to finish out my eighth grade year. Even though I knew it wasn't Leanna's fault that we had to move, I was still a pissed-off teenager about it and took it out on

everyone. That fury combined with my hormones turned me into a whirlwind of anger.

I had so much rage inside me. When I got to school, if something made me mad, then I would act out on it. I ended up getting into a bad fight, and they sent me to Soledad County Juvenile Detention Center in Fairfield for a couple of months. That was the first time I went to juvenile hall.

The juvenile jail was about fifteen minutes down the road from where my sister was working hard to try to make a life for us the way she did back in Medical Lake. We started having more friction as soon as I got there. She didn't treat me like a burden, but I felt like one. My older sister loved me, but she couldn't understand me.

The handcuffs on my wrists didn't help bring us any closer.

It was at the facility in Fairfield when I was introduced to the South Side Gangsta Crips in my neighborhood. That's also when I started meeting people from different neighborhoods in different parts of town and from different areas.

Some kids were terrified of being in there. No matter what tough element they exhibited to get thrown in juvie, it disappeared when the guards closed that door behind them and they realized that they couldn't leave.

The claustrophobia of the juvenile hall units didn't bother me.

I remember hearing kids crying in bed all night when their mistakes caught up with them. I never felt boxed in, I never felt claustrophobic, and I never felt sad. I was just angry.

I'd like to say I was fully prepared, but I don't think anything can fully prepare you for the reality of the experience until you're in it. You don't really grasp what it's going to be like when you lose the people you love or when you come inches from losing your own life. It doesn't hit you until the decisions you make start affecting the family you have. It's when you hear the worry in your loved one's voice as they wonder if that will be the last time they'll get to talk to you. How could anyone prepare for that?

Leanna tried really hard to pull me back into the safety net of the life she had built for us, but there was nothing she could have said that would have made me stay. I wanted to be my own man. I wanted to be grown-up. I wanted to feel in control over this life that I had felt powerless in.

I wasn't the only thing that my sister was up against as she climbed the ranks. She did multiple tours in Iraq and Afghanistan. A lot of her friends died during the war. Years ago I asked if she had watched the movie *Lone Survivor*.

I remember her getting very quiet, then she said, "I cannot watch that movie. Those were my friends."

My heart broke for her. I've always been able to feel other people's emotions, and in that moment I felt everything she did. She had been through abuse from my mom's boyfriends. She had taken on the role of our mother. She had fought in a war and lost her best friends. She dealt with PTSD and discrimination, yet she still showed up for our family every single time. It wasn't until I was older that I really started to think about everything she had done for me.

She was also a gay woman trying to serve her country while "Don't Ask, Don't Tell" was still the official policy in the United States military. The policy was instituted in 1994 under the Clinton administration and was in effect for seventeen years. It discriminated against gay, lesbian, and bisexual people who wanted to serve by preventing them from being who they were openly.

My sister wasn't even all the way out yet, and she gladly abided by the rule, but rumors are difficult to overcome. They could hurt your career at the time, even if they were unproven, because they can make it look like you're untrustworthy or at least not worthy of being in a leadership position.

She also donated her time to being the D.A.R.E. (Drug Abuse Resistance Education program) officer for my school district when I was in seventh grade. While she was holding this role, I

started selling weed. I sold to one of my classmates, who was caught showing it off to a kid in the back of the class. The teacher made him march to the front of the room and put what he was holding in his hand on the desk. He placed the baggie of weed on the desk, and the teacher asked him where he got it from. He snitched without hesitation, calling out my full given name, "Jeremy Ray Meeks."

The teacher called the principal, who called my sister. They went into my locker and found two ounces of weed and a bottle of Jose Cuervo, which was really concerning for Leanna.

My sister didn't need another scarlet letter on her back. Something that I feel like I've always been blessed with is consideration, but in this instance I didn't think about how my sister would feel if I kept making poor choices. I couldn't always protect her from the weight of my decisions, but I could try, and I did try the best way I knew how at the time.

My sister was exhibiting tough love to get me under control. She was just trying to give me some boundaries, rules, stability, and structure.

Had she not done what she did, I don't have any idea where I would be today. I'm not ever sure if I would be alive. There were many times when she could have given up on me, but she never did. When I look back, I realize there were a million other ways

my life could have gone had my sister Leanna not loved me unconditionally. I feel like so many people love with conditions.

It's rare to find people who truly love unconditionally. Even with family members. When I was going through a cycle of getting into trouble over and over again, she never gave up on me, and she had my back. Now that I am where I am, I thank God that he blessed me with Leanna. She is the most special person.

So, Leanna, I know that eventually you're going to read this, and when you do, I want you to know how absolutely grateful I am for you. You have inspired me beyond measure.

Spokane, Washington, 2000

In the summer of 2000, I went back to Medical Lake for Emery's high school graduation. My sister knew I missed my friends, so she let me attend. I wasn't supposed to leave California because I was still on probation for the fight, but there was no way I was going to miss watching him graduate. I was determined to be there, and I was screaming at the top of my lungs when he walked down that aisle in his cap and gown.

Because Emery and I were the closest in age, we were always together growing up. We struggled with many of the same things, and when we would experience moments of anxiety or depression, we would talk each other back up. He was my brother and my best friend.

We used to love going fishing and being out in the woods. As kids we would spend hours building tree forts and making bow and arrows out of strings and sticks. It was so nice to disappear into some good old-fashioned childhood fun.

I used to love talking crap to him on the basketball court. We're both very competitive. He would just laugh and continue checking me.

Even now we have this bond and this understanding. We don't have to say a word to each other. With just a glance, we know what the other is thinking. It even goes as far as being able to have full-on conversions with our eyes. We just look at each other and start busting up laughing while everyone else in the room is confused about what the hell is so damn funny.

I couldn't have been more proud of him. School was just as hard for him as it was for me, and here he was pushing through it. He got accepted into Eastern Washington University on a football scholarship, and you better believe I was going to be there to celebrate.

I was so happy being back in Medical Lake. I was so happy seeing my brother and all my friends again. I didn't realize how much I had missed them. I had a lot of love for my Cali family, but when I got back to Washington, I didn't want to leave.

I didn't openly discuss joining a gang, but most people

assumed I had based on my new style of wearing strictly blue clothing. I also didn't advertise that I was on probation and wasn't actually supposed to be there.

I didn't tell any of my friends that I was coming back. It was the last day of classes before the break, and I just showed up outside the high school. There were still a few minutes before school let out when my friend Shelby saw me through the classroom window. She announced that I was outside, and everyone crowded to the window to greet me. When the bell rang, they ran outside to hug me. It felt good to know how much I was missed.

No matter how long I go without seeing my Medical Lake family, every time I come back, it's as if no time has passed at all. There are no awkward hellos or uncomfortable small talk. We just fall back into the same familiar friendship we've always had.

I stayed with Shelby and her family at their house on Clear Lake, which sat a few miles outside of town. Her house was right on the lake. Shelby's family has always had an open-door policy, and it was the place everyone came to hang out. Shelby's mom, whom we called Mama Donna, was a kind soul, a free spirit who believed in talking to children like they were adults who could understand what she was saying. Early to the gentle parenting movement that is so popular now, she was very open and a very

good communicator. She used to be a lot stricter when we were younger, but once we hit our teen years, her parenting style changed. She didn't try to control or stop us when we wanted to go out to parties, but she would say, "If you're going to drink or smoke pot, then I'd rather you stick to this area where I know you're safe."

Shelby and my family have been close since we moved there, but during that time they became my family. They didn't judge my actions or treat me like a burden. Mama Donna has this thing about her where within five minutes of meeting her, you find yourself opening up and telling her your whole life story. All these kids would be sitting in the living room, and we would have these deep hours-long talks. They frequently resulted in some kind of massive revelation about your life.

Mama Donna and her boyfriend at the time, Steve, offered to let me live with them. They knew that California was going to bring me down a path of crime, and they saw nothing but potential in me.

I was ecstatic and agreed to stay right away. I wanted to be with my brother. They told me not to get my hopes all the way up because it wasn't completely up to them. They still had to talk to my sister because, as my adoptive mother, she had the final say about where I could reside and enroll in school.

They asked her permission, and she was okay with it because she was so stressed out by my antics. The military is not a nine-to-five job. It's all consuming. They judge you for who you are, not just what you do when you're working. It didn't matter that my sister was a dedicated member of the air force. I was her dependent and therefore a reflection of her. It didn't look good that I was acting out and getting a record as a minor in her care. Living with Mama Donna led to some pivotal moments in my life.

Mama Donna worked as an instructor at a modeling agency. She told me numerous times that I needed to go into modeling and acting. We even took headshots in the backyard once, but at that time I couldn't even imagine having that kind of life. It didn't make sense to me. I couldn't see myself as a model or as an actor, but they did. It was easy for others to recognize my potential, but it took me a long time to see it for myself.

It was during this time that I started getting into music. Emery and Shelby were both very musical. Maybe it's because they shared a birthday. They both sing really well, and Shelby had a Yamaha guitar that she would play while we would lounge on the porch. The two of them would harmonize, and the rest of us would freestyle rap over her playing. It was also the first time I ever recorded a track. I was at my friend Nick's house, and we

set up this old-school eight track recorder in his grandma's closet. I wish I still had those. Letting out some feelings in a booth was cathartic.

There was a group of us guys who hung out often. They were my boys: Adam, Justin, Jesse, Justice, Levi, Nick, Packi, Travis, and Jacob. They were just as wild as I was, and we took the meaning of partying to an entirely different level.

We would go to Long Lake and camp out on the beach for days. There was this huge hill that went right into the water, and the entire side of it was covered in sand. We would break down our beer boxes and turn them into sleds, then ride them into the water. It was that kind of regular teen shit that I had a blast doing.

Medical Lake was also pretty diverse in the type of parties there. On one end of town, you'd have a party in a barn, out in the woods, blaring country and shotgunning Budweiser next to a cow. On the other side of town, you'd go to this big-ass house party where everybody was hitting the Hennessy bottle, listening to hip-hop, and freestyling verses. Depending on your mood, you could just go down the line, hitting all these different spots.

Even though Mama Donna was relaxed in her parenting style and established softer boundaries than my sister, she still had some rules. In fact, because Mama Donna was so lax and understanding, she took it more personally when you crossed the

line. When she would ask me not to do a certain thing, there was no question that I was going to do it anyway. She would go out of town for two days and ask us nicely not to have a party in her space when she wasn't home. "It's just two days. You can have a party when I get back. Please don't while I'm gone."

Before she was out of the zip code, we would be putting the word out that the party was on. I didn't mean to be disrespectful. I didn't want to hurt someone who was so good to me. I just couldn't help myself.

Now that I'm a parent, I appreciate the actions of my sister and Mama Donna more than ever. I couldn't imagine what my sister was feeling when I would stay out all night. I'd get so stressed out about facing the consequences for that that I would decide it was a good idea to just not go home for like four additional days.

I remember a time when my boy and I were about to do a job, and I got a call from Mama Donna. She was always worried about what I was getting into, and she had this way of knowing when I was up to no good. At this point I'm convinced that she's psychic.

I put the phone on speaker, and she immediately asked me what I was doing.

She said, "Jeremy, I don't know what the hell you're doing, but

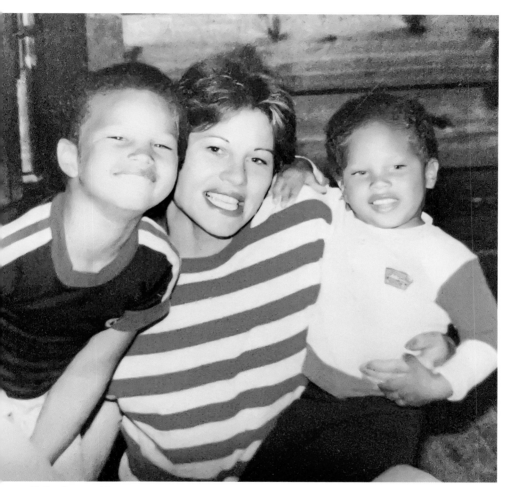

...mery, Katherine, and Jeremy

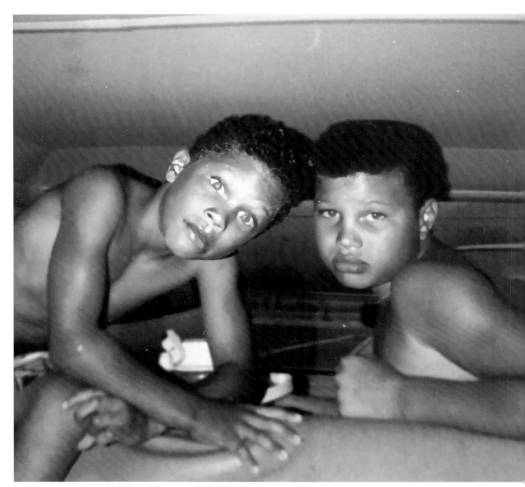

Jeremy and Emery

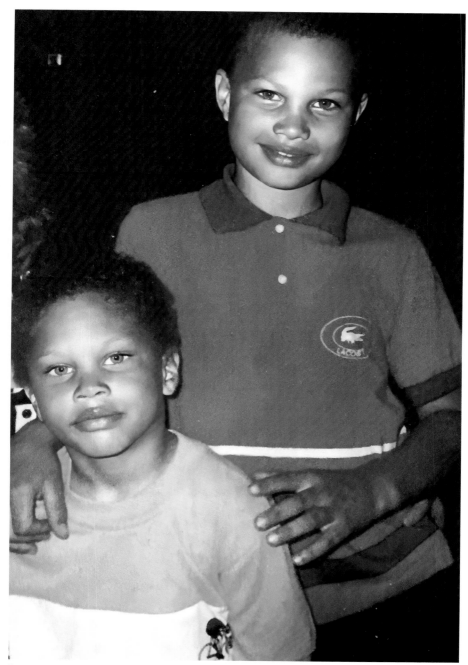

Jeremy and Emery

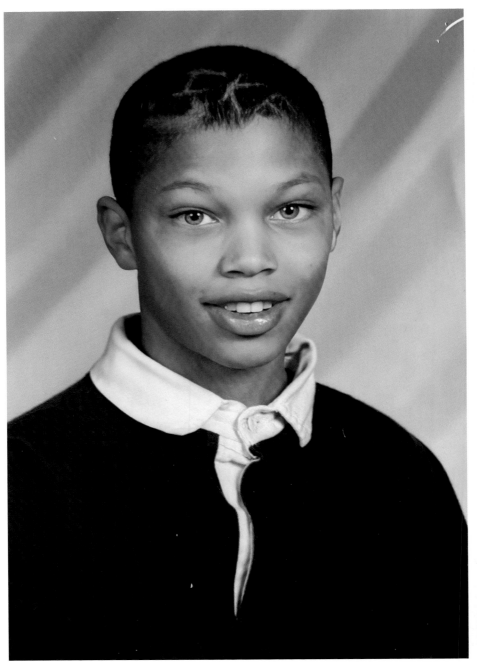

Jeremy

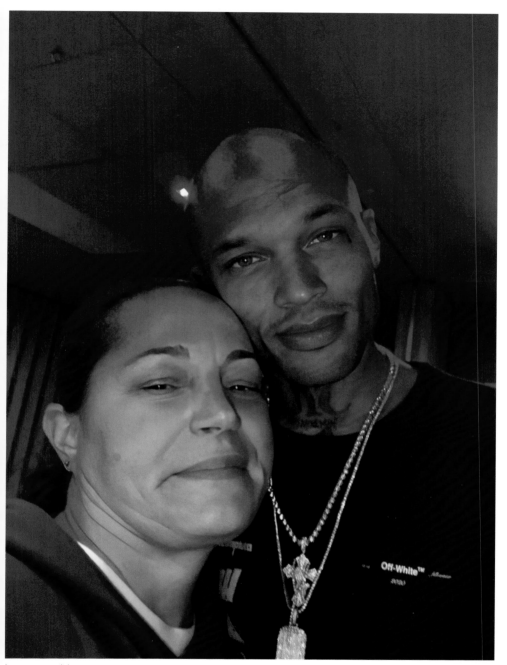

Leanna and Jeremy

Jeremy, Emery, Leanna, and Carmella

Jeremy and Carmella

Melissa and Jeremy

emy and Melissa

Jeremy and Jeremy Jr.

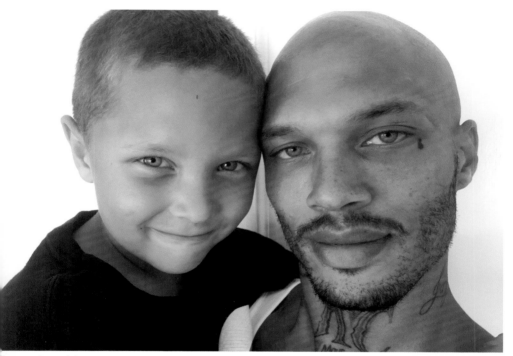

Jeremy Jr. and Jeremy

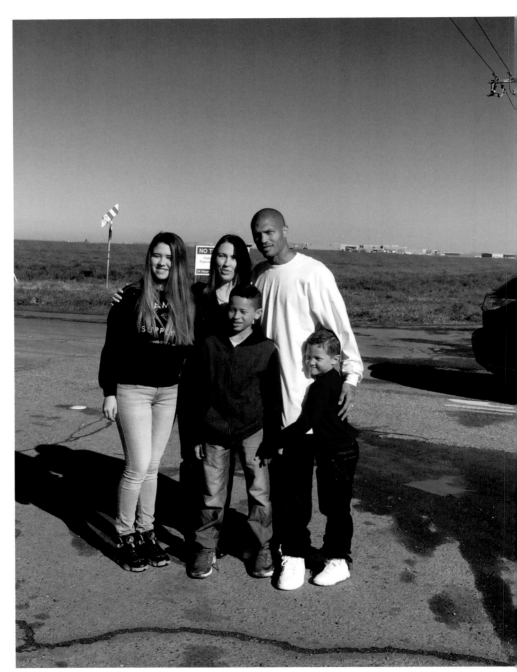

Elliana, Melissa, Jeremy, Jeremy Jr, and Robert

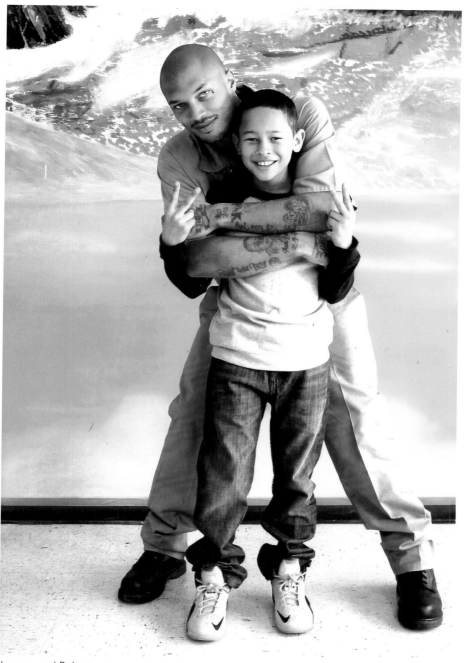

Jeremy and Robert

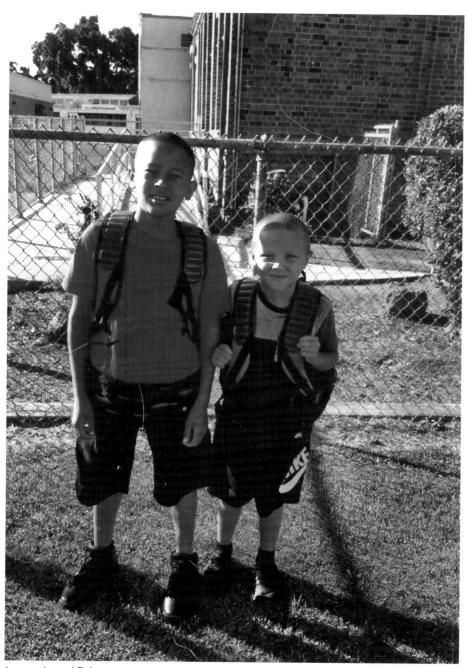

Jeremy Jr. and Robert

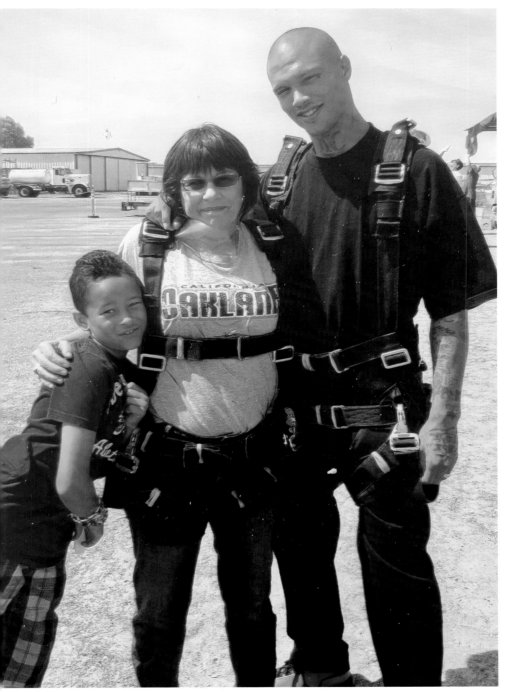

eremy Jr, Katherine, and Jeremy

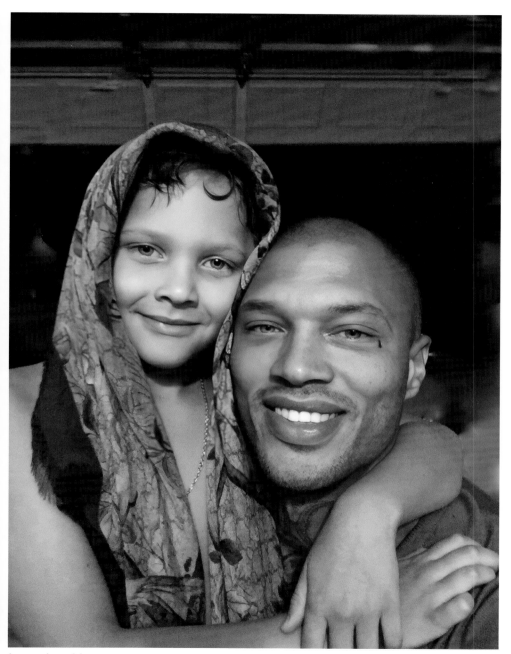

Jeremy Jr and Jeremy

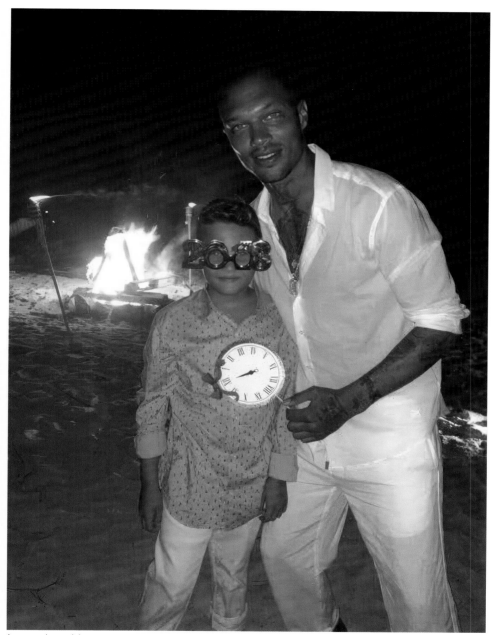

Jeremy Jr and Jeremy

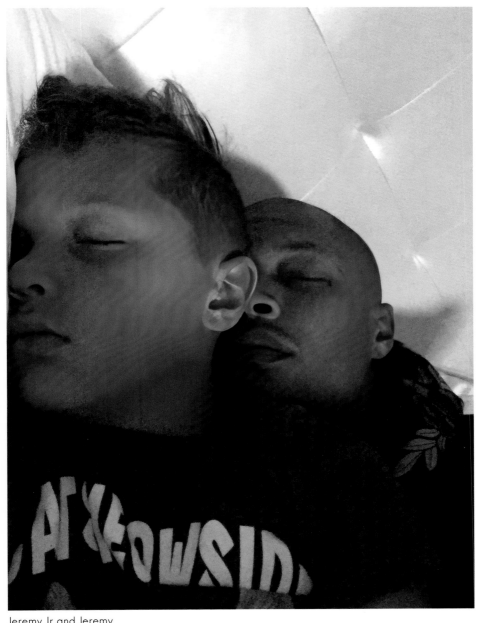

Jeremy Jr and Jeremy

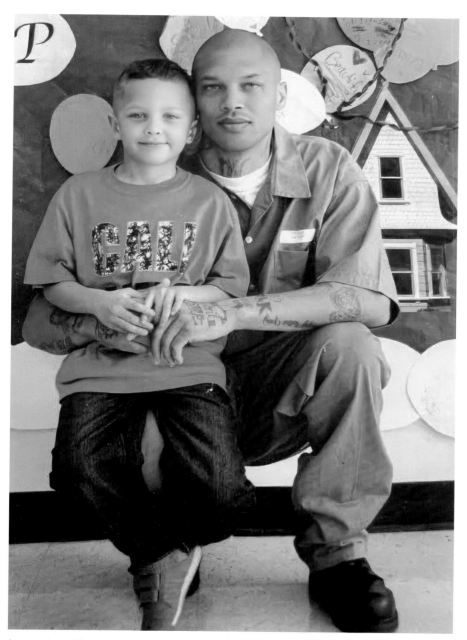

Jeremy Jr and Jeremy

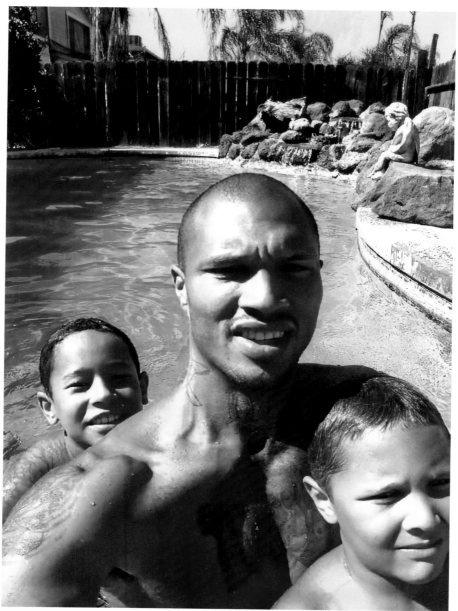

Jeremy Jr, Jeremy and Robert

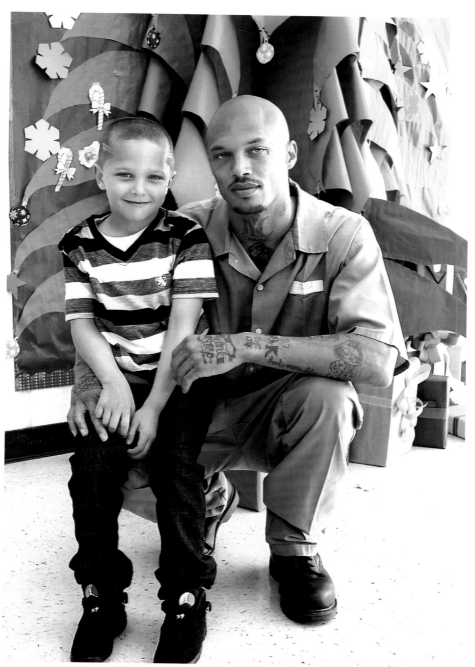

Jeremy Jr. and Jeremy

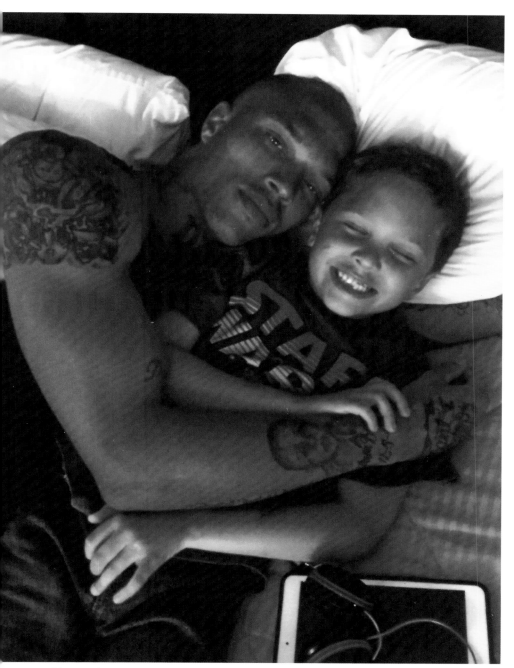

eremy and Jeremy Jr.

I keep getting flashes of you in my head doing . . ." and then she'd name a list of illegal things that she saw.

We were literally in the middle of doing exactly what she said. My boy and I got really quiet and didn't say a word. We looked at each other, wide eyed and in shock, then I told her I had to go.

All I could hear was her protesting and calling my name before I quickly cut her off and hung up.

T and I sat there in silence for a minute, contemplating what the hell to do. The outcome of her vision didn't end well for us, and given how dead-on she was about everything else, we didn't want to take the chance.

We immediately got on the phone with the rest of the boys and killed the entire deal. The other homies were probably thinking, *What the hell is wrong with these guys?*, but the two of us weren't taking any chances.

I realized a lot of things about myself during that time. I realized that because of my chaotic childhood, I was constantly searching for family connections. I also realized that even when I had loose boundaries placed on me, I had an innate urge to bust through them.

Mama Donna and Steve weren't comfortable with me partying as much as I was, and when they learned I wasn't supposed to be there, they said it was best that I go back to

California and finish out my probation. Although I understand it now, I was devastated then. We used to sneak into this abandoned farmhouse nearby, and I remember punching out the window, then watching the blood run from my knuckles. There I was, breaking windows again.

Mama Donna continued to pray for me and to be one of my spiritual mothers.

It wasn't long after I returned to California that I was back in juvenile hall.

The Crips in juvie spoke my language. They harbored the same pain that sparked my desire to shatter windows. I was always drawn to troubled kids who understood what it was like to feel that they couldn't live in between the lines set up for them.

As an adult, I recognize that it was no coincidence that I joined the gang less than one year after being separated from my older brother. I realize that, more than anything, I was looking for a father figure, someone who could teach me something about how to survive on my own in the streets.

There are a lot of misconceptions about Northern California gang culture. The homies welcomed me, but they didn't recruit me.

I wasn't some promising young kid who made one mistake and ended up corrupted by a group of manipulative big homies.

It didn't go down like that.

My big homie Já-Rocc actually pressed me when I said I wanted to be down. He pulled me aside not because he wanted to put me on the spot but because he wanted to make sure I knew what I was getting into. He wanted to know why I would want to join a gang and why I would want to be a Crip.

"Help me understand," he said. "Let me tell you what this is about first and foremost."

The reason was family.

My sister wasn't pushing me out of the nest, but I was easing out on my own anyway. I just felt like I had to. I knew that what was going on with me couldn't be controlled. Detaching myself from my family just seemed like the right thing to do.

"I'm saying a lot comes with this," he warned.

I had never had anyone speak to me like that at that age. No one had really bared their soul 1000 percent with me. It was important to him that I understood wholeheartedly. Through this conversation I could feel the severity of the consequences associated with the choice I was making, but because of the way the trauma I had endured since before I was born was embedded into my cells, I was still committed. I felt like it was the best option for me at the time.

I didn't even get put on that day because Já-Rocc wanted me

to sit with him and really think about the choice I was making. He knew this was a decision that would affect the rest of my life.

After I made the decision, I told my sister that we were going to play ball at the local park. It was there that I got jumped in.

I came back battered and bruised. Each mark on my face represented a sign that I had a new family. Almost as soon as I joined, I got my first tattoo on the inside of my left forearm: a large SSGC (for South Side Gangsta Crip) in horizontal block letters. My homie had just gotten out of jail and had made a prison-style tattoo gun. I watched him make it from an old Walkman CD player. He removed the motor, got a guitar string, used the inside of a ballpoint pen, and attached it to the spindle that runs the motor by soldering a tiny hold. Once that was fastened, he removed the ballpoint and used it for tattooing.

Body art let people know where I was from. It was a way to let my frustrations out and also a way for me to show my emotions using art as my form of expression. It helped represent the chaos I was feeling inside.

I was young and impressionable. It made me the perfect soldier. I latched on to the homies, and I was the biggest sponge.

I did things during this time in my life that I am not proud of. It felt like we were always in a constant battle. Always getting

run up on, always getting shot at, someone always beefing. But my boys were by my side the entire time. We were there to protect one another.

The homies instantly became my family. Their moms became my moms, and their grandmas became my grandmas.

During that time I received more unconditional help than I ever would have thought possible. My homies and I shared clothes and food. Their parents bought me Christmas presents, and one of their mothers even tried to enroll me back in school. It was a bust from the jump, but I appreciated the effort.

They understood me.

I was bouncing from place to place, from homie's house to homie's house, crashing on couches. There were times when I slept in the broken down cars in their driveways.

They always made sure I was fed and clothed. They didn't care what I did or what trouble I got into. Their support didn't come with the kind of strings I was trying to avoid. I didn't have to try to fight what was going on in my head or to prove that I wanted to act right. At that time, I didn't want to act right. I had the opportunity to feed the worst parts of myself.

I rewarded them with unconditional loyalty. For a long time, I dove into a revolving door of prisons. I was constantly being apprehended and released for this or that. Because I was in and

out all the time, I got used to it. As long as I had an end date to think about, there was no problem.

When I would get hurt, I would roll out of that hospital bed and head back to the block. It was part of the game. Everybody was going to get caught up sometimes, and we knew it was a part of the lifestyle.

Everyone had their role to play. There were rapping homies and hustling homies. Some homies were known for getting money, and some homies knew how to rob houses. There were carjacking homies and check-scamming homies. I was a problem-solving homie. If someone had a problem, I would figure out a way to fix it.

I protected the squad, and they looked out for me in exchange.

Já-Rocc taught me about how to conduct myself and about morals. There is such a thing as honor among thieves, and he let me know that it was possible to try to do the wrong thing in the right way.

When I was released from probation, I could set my original family free. But Leanna didn't want to be set free.

She knew I was in a gang, and she made one last attempt to put me on the path she thought would be best for me. She just

couldn't take seeing me destroy myself anymore. She sent me to my mom's house, thinking that another change of scenery might have a positive impact.

CHAPTER 4:
WINDOW PAINS

Spokane, Washington, 1999

I was gangbanging and in and out of juvenile hall, so Leanna made the decision to send me back to my mom in Florida. It wasn't an easy choice for her, but every time I got in trouble, she'd subsequently get in trouble with the air force because I was her dependent. So I went to school in Florida. But only for a couple of months. Then I returned to the West Coast.

I left Leanna's house for good shortly before my fifteenth birthday.

Even after I left, she looked out for me. I would be in and out of juvenile hall, and my sister would come get me before I would run away. No matter how hurt or disappointed she was when the phone rang, she showed up.

Back in 2001, I caught a case that ended with me being sent to a group home for what the judge thought was my own protection. I had been assigned a new judge who said that she wasn't going to send me to a juvenile hall run by the California Youth Authority because she didn't want to ruin my life, and she thought I would never make it out if she sent me there because I would catch a lot of time.

The group home was in an iconic area of Vallejo known as the Crest. The region is notorious and allegedly birthed the infamous romper room bank robbers who supposedly tossed one-hundred-dollar bills at people on the street after pulling off their heists for a full fifteen years. Lots of rappers, like Mac Dre, are from the area and have immortalized it in song.

It was worse than juvenile hall because not everyone belonged there. Some people were just abandoned and in difficult situations.

All the counselors at the group home were just regular people off the street. They probably had some good intentions, but they weren't very effective at turning around the lives of the residents or in managing their own lives for that matter. They mostly just let us do whatever as long as the house was clean. We were supposed to be homeschooling and trying to find other ways to make ourselves productive members of society by preparing for adulthood, but they never pushed school, life skills, or anything besides cleaning that house. It was their top priority.

Their second was hustling.

The jobs they had didn't pay well, so they were open to finding other ways to supplement their income. There were some counselors who were literally selling us weed and other things as a side hustle. Based on their examples, it was hard for them to

convince us that going to school and getting a job was somehow going to make everything better in our lives.

They had sacks of weed that came in every Friday. We got weekly stipends on Fridays, so they were tracking we had money and were bringing it in based on that.

Some of them even turned to the kids for enforcement. They had kids punch on other kids because they owed them money. It was anarchy.

Even the counselors who weren't engaging in these activities were fully aware of what was going on. They just didn't care enough to risk beefing with their coworkers to intervene.

Sometimes they had speakers come to the group home to try to motivate us, but they were never people we could relate to. There were moments when I could have used somebody who had gone through the same struggles I was facing, but there never seemed to be anyone like that on the line-up.

There were about eighty-eight kids in the group home from all different walks of life. They came from different neighborhoods and from different cities. There was no one there to govern us. The counselors got paid through government grants, and there were little funds for implementing proper oversight.

Because not everyone was from the same crew, some were

clicking up for protection, and people were getting jumped by them. Kids can be really brutal when they're in pain, and when you don't have any protection, it can be even more intense.

I still had that thing in me about not wanting things to go down in a way that I didn't think was fair. Some of the counselors were bullies too. They always tried to bark on kids they thought were weak.

Seeing people who were minding their business getting terrorized bothered me. I jumped in to defend some of the kids. I wasn't the greatest with the battles brewing in my mind, but I could take quick care of the ones happening in front of my face.

There was this one boy who I found tied up and shoved under his bed. I untied him because I wasn't going to leave him there like that. I ended up getting into a fight with the kids who put him under there.

The counselors would flip on us at the drop of a hat. One second they were cool, and the next second they were tripping about things like curfews and smoking in the bathrooms, like they weren't just rolling a blunt with us a few days before.

Things that were normal occurrences became a huge deal whenever they were pissed off about something and felt like they needed to exert control over their charges to flex the fact that they could. Some would abuse their power, hurt people, and even

come to work and terrorize certain kids. One counselor bullied my roommate ruthlessly.

My roommate and I used to sneak out of the large picture window in our room by removing the screen. The house was actually pretty nice. You wouldn't have been able to tell what was going on inside if you didn't know. Our room overlooked the street, and we used to climb up to the roof to smoke cigarettes.

It was a pretty open secret that we used to kick it up there when we got bored.

One night while we were smoking and talking, my roommate started hitting one of the counselor's windshield with these big rocks. He would need a full replacement when he was done.

The counselor left for his shift and found that his windshield was destroyed. It was obvious that somebody had hit his car with rocks. He immediately ran upstairs after seeing the damage.

He literally kicked the door off the hinges. The force of his boot shattered more than the door itself. It took down the whole doorframe.

He grabbed me out of bed, thinking I had done it, and slammed me against the wall so hard that the sheetrock broke and left an imprint. When I repeatedly denied knowing anything about the windshield, he dropped me with one punch.

After he hit me, I knew that I wouldn't be finishing my

court-appointed sentence there. As soon as he walked out, I was already orchestrating my exit.

Within a day or two, I was all set. Tara, my girlfriend at the time, picked me up. She was a beautiful girl from my neighborhood. She pulled up in a Mazda 626 and got me out of there before anybody noticed. From the moment I left, I was officially back on the run. During that time, I met up with my friend Jake. We were driving around through the Bay Area, stopping in different towns and hitting different licks. The two of us brought in about $2,000 almost every day.

CHAPTER 5:
POP GOES THE GRILL

California, 2001

My friends Jake, Meezy, Ant, Josh, and I stopped at the Jack in the Box in Antioch, California, to meet up with our friend Chico. It was around midnight on a Friday, and the place was packed. After we got our food, we went outside to eat on the restaurant patio. From where we were sitting, we could see the entire area.

I had just hit a lick and scored a ton of money from it. I'd gotten a set of custom gold teeth designed with the insignia for the South Side Gangsta Crips emblazoned on the inside with diamonds. I had gone from having flaps on my heels to diamonds on my incisors.

I carefully took the gold teeth out of my mouth and stuck them in my pocket before we started eating.

As we ate, I heard Jake say, "What are you looking at, homie?"

Racial tensions in the area were really high at the time. We had been warring with a Mexican gang. There was so much history and conflict on those streets. Long before I'd joined up, we'd been in a forever war with the Brown Street Norténo's.

I looked up and saw this really old-school black tinted Suburban. It stopped and backed up. There was a guy reclining in

the back seat. He wasn't even fifteen feet away. The corners of his mouth curled up into a sly smile, but his eyes told a different story.

Then boom!

It happened so fast. I felt the force of something hit my legs, and for a second I heard that Tupac and Scarface song "Smile for Me" in my head. I started feeling the burning of the bullets. He had his .40 caliber on us.

I ran into the front yard of the house behind the drive-through. I looked down and saw that my legs were covered in blood.

I was the only one who had been struck with live rounds. Everyone else got hit with bullet fragments. I caught one ricochet in my foot, but I didn't feel it until later.

With the adrenaline surge, I managed to get behind the wall to one of the drive-through lanes. People eating beside us were screaming and ducking behind cars. Those who had been waiting on their food in the parking lot sped off to get away from the chaos. While I was making the jumps into the lane, the gold fronts that I was so excited about just a few minutes earlier fell out of my front pocket and onto the asphalt of the opposite drive-through lane.

The people who took off from the drive-through ran them over. They were crushed and disfigured from the weight of their

tires. When I fell, I saw the shiny twisted metal on the ground next to me.

The mangled gold glob shined underneath the security lights. I was broken up at the sight of them. The fronts and the bottoms just folded into each other as if they were made of nothing.

Some of the diamonds popped out of their settings, and I saw their shine sparkling out of a small puddle of crude oil that was right next to my crinkled-up gold teeth as we walked toward the inside.

I risked my life and spent like two grand on those pieces of jewelry for my teeth, and I didn't even get to own the tops and bottoms I copped for a full forty-eight hours. I didn't see the value in my own life or that it was worth so much more than that.

We walked into the Jack in the Box. It was completely silent. The lines that had been packed with people flirting and joking moments ago had disappeared. Now there were just a few people left cowering under tables and crowding into the walk-in freezer in the kitchen.

The three of us made our way into the bathroom, and the restaurant manager ran into the room hyperventilating.

"Just stay here," he said in between breaths. "We already called 911. The ambulance is on the way. They're going to help you."

We knew we had to get out of there before the city officials arrived. A ride in the ambulance would have been a one way-ticket to juvie.

The police were pulling in just as we were going out to find some help on our own. We went to our friend Chico's house. It was just Chico, his little brother, and his mom living there because his father had recently passed away.

There were a lot of steps to get to their apartment. I was bleeding everywhere, and those steps felt like climbing a mountain.

Chico came out and froze at the sight of us. "Jeremy just got shot. I got hit with a ricochet," Jake said. Before Chico could even say a word, his mom flew through the screen door and told us to take our gangster bullshit away from her doorstep.

We didn't blame her. It wasn't uncommon for people beefing to drive around neighboring streets looking to finish the job after a shooting. She didn't want to add her son's name to the list of casualties. She flipped out on all of us.

"Get out of here!" she screamed.

My injuries were not life threatening, but I didn't know that at the time, so I was overly dramatic.

"My legs don't work. I need help!" I pleaded.

I was only seventeen, and I had just been shot numerous time. I was on the run from the authorities, and I didn't know what to do. I was losing my mind.

The homies helped me back to Vacaville, where another of my homies lived. His mom was a registered nurse and did some contract work for a pharmaceutical company. She took pity on me.

She sprang into action when she saw us. She gave us everything we needed to get through the entire ordeal. She patched me up like she was a one-woman emergency room.

After I got shot, I stayed in the hood house to recover. I took a few days to chill, then not even a week later, I went from worrying I would never stand the same way again to playing all out with my boys on the basketball court.

Every year we had a day when we would barbecue and play basketball. All the homies came out. It was a mandatory morale thing. If you were breathing, you were balling.

I was still healing and bleeding a little, but I was young enough not to care. I felt invincible, like Wolverine from the *X-Men* or something. I saw the blood and I felt slightly sore, but I was in the moment and alive. It felt like the worst had happened and nothing else could be as bad as that.

Chico's mom was right about the fight not being over. Two weeks later I was still healing up. I went to the store and was

walking back to my boy Rip's house. The Brown Street Northerners caught me and beat me viciously with baseball bats.

I hit one, and when I turned for the other, I saw a flash of pink metal. I was struck again and again as I tried to get up and fight my way out of the situation. I was on all fours, and they were destroying me. I finally realized I wasn't going to be able to get up, so I just curled into the fetal position until it was over.

They thrashed me with the bats until they tired themselves out. They slapped some skin off the back of my head, but they really did a number on my back.

Bats accomplished what bullets couldn't. I was permanently injured.

This incident irreversibly damaged the L1 vertebrae in my spine. One side of my back was bulging out, and the other side was kind of collapsing as I laid on the ground unable to move. There was no ducking the ambulance or anything else. I was totally out of commission.

I urinated blood for a good six days because of the severe damage to my kidneys.

I should have gone to the hospital this time, but my hood house was where I went to heal.

CHAPTER 6:
ON GANG

San Quentin Prison, California, 2004

At eighteen I was thrown into San Quentin. That was in 2002. It was the first time I had ever been to prison. I was there for six months before doing another year and a half at Soledad.

I remember a time when my sister Leanna had come to visit me in Soledad, but when she arrived, there was a riot. Unsurprising when you're looking at a population of Mexican Mafia, Aryan Brotherhood, Nuestra Familia, Nazi Low Riders, the Bloods, and the Crips. The entire prison went into lockdown, including the visitors center, and she was stuck there for six hours. She was terrified and had no idea if I was alive or dead.

Two weeks later, she came back again, only to have another riot go down. This time she was locked in for nine hours.

A lot of people don't want to come to the prisons because of the way they're treated. Even the visitors are handled like criminals. They're searched and regarded as smugglers. Then, to top it off, two riots go down within weeks of each other.

It happened all the time. At a certain point, you just expect it and you think to yourself, *Which one of us is going to die today?* You never know who you're going to come across or what

interactions you'll have. At one point during a prison stint, I was in a cell next to Charles Manson, the infamous cult leader and criminal mastermind behind the so-called Manson Family, the quasi-commune that arose in California in the late 1960s. The same Charles Manson who orchestrated a series of gruesome murders, most notably the killing of actress Sharon Tate and several others over two nights in August 1969, a crime that shocked the nation. Manson's philosophy, a twisted blend of pop culture and apocalyptic prophecy, manipulated his followers into committing the murders, believing they would ignite a race war. My cell neighbor remained a figure of fascination and horror until his death in 2017.

The first time I realized that I was standing face-to-face with Charles Manson, I was cuffed and waiting to go to the shower block for a hose down after being pepper sprayed because of a beatdown that had happened a while before—which was how I'd wound up in the SHU (Security Housing Unit) in the first place—and Manson was locked in his cell. I have to be honest, back then I didn't know much about him. I recognized him from videos and stuff, but I didn't really know the story. I wouldn't say we had a deep and meaningful conversation. It mainly entailed him screaming racial slurs at me, even with the walls between us. I mostly remember the swastika tattoo. After the three-minute

shower, they brought me back, and I could see him pacing at the rear of his cell, mumbling to himself.

It wasn't much of an encounter, but the thing I remember most is that this was the first time I'd seen anyone get bags of fan mail. Six days a week, he got these green army duffel bags filled with mail, every single night.

San Quentin is a scary place. Not only because it's one of the most dangerous prisons in the country but also because it's the oldest prison in the country that's still functioning. When you step into that place, there's a dark energy to it. It isn't just what's going on at that time that lets off dangerous vibes. It's like you can feel decades of tragedy trapped inside those prison walls, and there's no escaping it.

It's the kind of place they take the Scott Petersons of this world. I remember his arrival, as it followed just behind Tookie's Williams's, who was a founder of the Crips. I recall hearing these huge twenty-foot doors opening, and the police shouting, "Escort! Escort!" and then climbing up to the second tier. There was Tookie. I instantly recognized him, even though he was shackled, chained up to the waist; he was just massive. You could feel how serious he was. I was throwing Cs at him with my arms, really big Cs. It wasn't the first time I'd seen him. The first time, they'd stripped me naked and stuck me in a dummy cage for

hours with no food, for no other reason than to be humiliated for throwing the gang sign, those bitter winds blowing in off the coast. Brutal. Now Tookie's special on so many levels. Sure, he was one of the founders of the Crips, convicted of multiple murders, but that's the one-dimensional summary of who and what he was. During his time inside, he changed. I mean a proper transformation. He became an advocate for peace and ending gang violence. He wrote kids' books aimed at deterring them from gang life. By definition, Tookie was what they talk about when they use words like *rehabilitation* and *redemption*.

This time, after they led Tookie through, the next thing I know they're shouting, "Escort!" again and walking Scott Peterson behind him. As soon as they brought him in, a whole bunch of inmates start spitting on him. Nasty thick loogies hocked from the third and fourth tiers. If you don't recognize the name, Scott Peterson was convicted of the murders of his wife, Laci Peterson, and their unborn son, Conner, in Modesto, California. Laci was eight months pregnant at the time of her disappearance. Her body and the body of her unborn son were found months later in San Francisco Bay.

The tragedy led to the signing of the Unborn Victims of Violence Act (often referred to as Laci and Conner's Law) by President George W. Bush in 2004, making it a separate crime to

harm or kill a fetus during the commission of a violent crime against a pregnant woman.

I grew up in a prison. I went from being a boy to growing into a man in a prison. I learned about respect in prison, and I respect everyone as a human being. I have also learned to demand the same respect from other people as I'm going to give everyone. That's something that was cultivated in prison. You learn a lot about yourself. You really have your fight-or-flight response tested.

It scares me to think about it now, but I used to run headfirst into any altercation. If I felt like I was seeing some kind of injustice, my first instinct was to fly right in there and intervene. However, I didn't use my words at that time. The only line of defense I knew how to use were my fists, so I would go in fighting.

There were times in prison when I turned myself into a torpedo. I harbored all these hurtful feelings, so when I got into those moments, it was like my way of letting out my pain and also wanting them to feel my pain. I realize now it was because I was hurting. And hurt people hurt other people.

So in a way, given where I was in my life, prison was almost the perfect place for me. It was a place where I released all that hurt I was holding on to. I feel like a lot of us were that way. You

have hundreds of these hurt people thrown into a box together, and it was a recipe for complete chaos.

The authorities were plugged into the details of the gangs, and the paperwork on your jacket indicated what gang and set you were with. After I became a Crip as a teenager and came in with identifying ink, I was placed in that category.

The paperwork that I was labeled under was Northern Crip, so whether I knew a homie personally or not, we recognized each other when we got inside, and we were still a family.

Family sticks together, so when some shit went down, it didn't matter whether it was on the inside or on the outside; we all stepped up to the plate. That's part of it. I have your back and you have mine.

Eventually, my points were kicked up so high from all the altercations that I was involved in through the set that I was marked as a level-four threat by the prison system.

Inmates are given an official classification score when they go through intake. The score is ranked from one to five. In level-four facilities, the walls get thicker and the stakes get higher. One wrong move could send you home to your family in a body bag.

Your score is based on the severity of the infraction that put you in prison. It's also based on things like your age and whether you have organized crime connections. It can be adjusted

throughout the years, but with the way I was moving at that time, it was unlikely to decrease.

Despite the way I was living, I was actively trying not to die. I was acutely aware that a level-four facility was more dangerous than the previous institutions I had been in.

Level-four environments are full of inmates who have been given life sentences.

When you're in a situation where everyone has a life sentence and they know they aren't going home, that's a different kind of danger.

They don't care about going to war, because they know they'll never have a shot at peace. What they do care about is those among them who have release dates. It's not like the movies. It's very real, and it's about respect and trying to resolve situations without going to war, but if it goes there, then it's real. A lot of those prison fights can go to the death. I've heard my neighbors fighting on multiple occasions. I would be in my cell and hear one cellmate snatch another cellmate's soul right then and there next to me. Everything would go quiet, and I would just feel them slipping away.

They don't care about kicking off a riot. They don't care about anything. I've been in multiple different prison riots. These situations are like hell on earth. There was a domino effect in

those moments. This person has a knife on him and that person has a knife on him. Everyone was stabbing everyone everywhere. The air was filled with the metallic scent of fresh blood. You would look to your left and your right, and death was just leaping out at you.

People who talk too much never see anything, because they're spending too much time running their mouth. I learned to sit back and watch. I would quietly observe the area, reading the space and reading the people. I was able to spot every single move that was happening on the prison yard. I saw every knife get passed, I saw every little bit of drugs get sold, I saw every move someone was about to make. It proved to be a very useful skill to keep my boys and me safe. Things get real inside there. It's like a world inside of a world.

I was there when they executed Tookie Williams. Arnold Schwarzenegger was the governor of California at the time, and he held the power to grant clemency or to commute the death sentence. And like I've already said, Tookie was a different man from the one who went inside. Lots of prominent figures in the entertainment industry, civil rights activists, and anti-death penalty advocates petitioned Schwarzenegger to spare Williams's life. Schwarzenegger had previously expressed his support for the death penalty, and he faced pressure and moral dilemmas regarding Tookie's case because of the high-profile nature of the

gang founder's transformation and activism against gang violence, but ultimately he denied clemency, and the execution went ahead.

That morning they let us out of the SHU. In truth, he was executed at midnight, but most prisons were locked down that day in fear of retaliation over it. We came out knowing that any time Bloods and Crips get into an altercation, there's usually something else that happens, because some line has been crossed. But that day, there was this aura about the yard, because everyone knew Tookie had been executed, and there were a lot of OGs in the yard that day who knew him personally. Which made it crazy that this captain, all by himself, just walked across the yard. We'd hashed out everything we needed to, then these two youngsters from Los Angeles, one from East Coast, the other from Rolling Forties, rushed him and stabbed him a bunch of times. They left him in the fetal position. It happened so fast. No one in the gun towers saw it. No guards saw it. After a while other inmates would walk by and stomp his head or kick him in the face. This went on for maybe ten minutes before the alarms went off, and the corrections officers came in thirty deep to get him out of there on a stretcher. Yeah, they made a pretty criminal mistake that day. More than one.

Tookie's execution got people talking about redemption and

rehabilitation and the death penalty. From where I am in my life now, I have to believe that the entire purpose of incarceration has to be about rehabilitation, the potential for personal growth and change, and, ultimately, redemption.

It may seem odd, but for a large part of my youth, I only felt comfortable when I was locked up. Prison is as scary as hell, but I didn't know how to live in the outside world. I didn't know how to take care of myself. I didn't know how things worked outside of those walls because I had spent so much time inside.

When you're in prison and a full-blown prison war breaks out, your boys are all you got. It creates a bond that others cannot understand and one that will never be broken. We protected one another, saved one another's lives, fought together, and would die for one another. And we damn sure shed some tears. When you spill blood with a person to protect the ones you love, you really learn a lot about them and about yourself. They're my boys and they'll be my boys forever. I couldn't have made it out alive without them.

I've always had different paths I could have gone down. Everybody has a choice, and I picked mine. It caused a lot of pain, I did a lot of stupid shit, and I used to have this seriously uncontrollable urge to travel down the path of most resistance. A path of chaos. But as I got older and started evaluating my life

and my choices, I think maybe I subconsciously gravitated toward that path because it was a part of God's plan for me to have that experience.

Maybe he knew that one day I could be a voice for so many others who are going through the same things. You can't really understand something unless you're in it, and when you're in it, there's nothing like being able to talk to someone who's seen what you've seen, felt what you've felt, and cried like you've cried.

God always has a plan, but sometimes it just takes a little longer to see it.

CHAPTER 7:
ON THE ROAD AGAIN

Susanville, California, 2005

When I got out of Soledad, my family was terrified for my safety. I will never shake the memory of my mom pleading with me on the phone to come to Florida. She and my sister Carmela were living there at the time. She was crying so hard that I could barely understand her. She was afraid I was going to get killed and she was going to lose her baby. I knew in my heart that she was probably right. I couldn't keep doing what I was doing, not with the gang stuff, not with prison, and expect good things to come from it. So I packed my bags again and was on the run to Florida.

I moved in with my sister Carmela, my niece and nephew, and their father. Carmela was also the wild child in the family. We had that in common. We've had this bond that has been unbroken since we were young. She's older than me and had her first child at fifteen. I was only seven at the time, but I remember looking up to her. When we got older, we loved to play pool together. That was our thing. We would play pool and watch people, making up stories about what we thought their lives were like or what kind of conversations they might be having on the other side of the pool hall. I've always considered myself to be an

intuitive person, so it was fun trying to put those skills into practice.

I hadn't seen Carmela's children, Jazmon and Dominique, since they were babies, and I couldn't believe how much they'd grown. It's amazing how fast it goes. It felt like I had just held them as babies, and now they were teenagers. They had these incredible personalities all their own. It was so fun to be able to joke around with them and ask them about school and their friends. I was so happy to be staying with them and seeing them all grown up.

Jazmon and I have always been very close. I even got her name tattooed on my neck several years ago. For a really long time, anytime someone saw it, they assumed that it was a girlfriend, and I would have to explain that no, it's my niece, and yes, I love her so damn much that I tattooed her name on my neck. She was my first niece. The first little baby born into the family, and I couldn't be prouder of the woman she's become.

She made me an uncle at seven years old, and I remember thinking how cool that was. Even at that young age, I knew the second she was born that she was my heart, and she still continues to be. Now watching her become a mother and raise her own kids has been such a privilege. Both my niece and my nephew have become amazing parents.

My nephew, Dominique, just recently had his first baby too. I love that our family keeps getting bigger and bigger. Growing up, he always had these bruises all over his face. It was like he never really learned how to walk. Once he learned to stand up, he would lean forward, and the momentum from his head would catapult him into a run. When he would try to go around a corner, he'd be moving so fast that he couldn't stop, and he would just smack his head right into that corner. I can't tell you how many times he missed that corner. He's been like that his whole life. He goes headfirst toward something, and once he gets going, there's no stopping him.

When I went down there, they were teenagers and were all up to date on the new social media outlets. I had never been on social media before, but they convinced me that I needed to join in with the rest of the world, so they made me my very first social media page on Myspace. I remember them getting so excited when they were adding all those little music boxes and pictures to my site.

I loved watching their zest for life. It made me feel so good, and after everything I had gone through, I knew being there was exactly what I needed.

When I moved into Carmela's, we went to this church, and it really changed my outlook. I had gone to church in my younger

days, but the way some of the pastors spoke, it didn't make sense to me. Some were very judgmental and hateful. It always sat wrong with me. So, for a long time, I kind of turned away from religion. I didn't realize until I started going to this church how important my spirituality was and how much I needed a relationship with God in my life.

The preacher's name was Pastor Dempsey, and his church was full of love and acceptance. He made learning about the word enjoyable. He made it make sense. He wasn't judgmental or hateful. He was full of love, kindness, and compassion. The church was filled with retired gangsters, unwed mothers, and stickup kids, and no one was looked down on. A lot of times people immediately step back when they see my tattoos, but I never felt that way here. It was always just love.

They welcomed me with open arms, and I even joined the choir. I never considered myself a singer, but there was something about standing with that group and singing songs of praise that completely uplifted my spirit. I was able to start really understanding my relationship with God. I'm so happy that I was able to find that peace. It completely changed my life and my perspective. All it takes is one good person, one good person to speak with love, and it's amazing the ripple effect it can have on your life.

Pastor Dempsey was by far the dopest preacher I had ever met. He wasn't sanctimonious at all. He listened to his parishioners and brought them comfort instead of persecution. I was comfortable talking to him openly about what I was feeling. His understanding of the word was impressive, and there was zero judgment when you wanted to ask him a question about the teachings being spread during service.

We had some really deep conversations about forgiveness, healing, and self-love. He truly believed that God had a plan for everyone's life. He told me that he saw God had a plan for me and that it was much bigger than anything I could ever imagine for myself. He explained that once I submitted my will to God, I would see it.

His tone was heavy with certainty. I couldn't see the vision that God placed on his heart for me, but he made me feel it.

Throughout my life, I had been receiving signs that would guide me toward Jesus, and when I was younger, I didn't realize how much I needed Jesus in my life. I think I closed my heart to God because of the pain that I'd felt for so long, but through all the experiences I've had, they were pulling me back to him. Moments like the ones with Pastor Dempsey, and the moments that occurred later on, were all meant to show how important it was for me to open my heart to Jesus.

I'm so grateful for Pastor Dempsey for helping to open my eyes and open my heart. It took a while for me to see it, but I finally did.

I spent six months with my family in Florida, but being on the run from the law did not allow for many options to make money. When I look back now, I realize that I had many other choices. I could have reached out to the pastor and asked for his help or guidance on my situation, but I didn't. I got it in my head that I needed to figure out a way to make my own money. My sister Carmela had a family she was trying to take care of, and I'm not the type of person who will not contribute. I got it in my head that I either needed to provide or move on.

My friend Craze was living in Spokane, Washington, and I was telling him how stressed I was about money, so he offered to set me up back there. He bought me a Greyhound bus ticket that very same day, and soon I ended up traveling across the entire United States. Those Greyhound buses are not that comfortable, and it took days to get there, but, oddly, I still liked the ride. I was no stranger to claustrophobia, and I enjoy meeting new people. I've learned that absolutely everyone has a story if you care enough to listen.

I've had the most interesting experiences during my interactions with strangers. On multiple occasions, I've had

people stop me randomly on the street and tell me that I'm an empath.

There was this woman I bumped into on the sidewalk once. When I apologized, she just looked up at me and said, "Oh wow, you're an empath," and then casually walked away.

I couldn't help but smile because I've always felt that way. I've always been able to feel other people's emotions. I think that's another reason why I liked riding the bus. Not only did I enjoy hearing their stories but also I liked being able to connect with those people on an empathetic level. When I got back to Washington, I stayed at Adam's and Mama Donna's house sometimes, but mostly I stayed at my brother Emery's place. He was playing football for Eastern Washington University and lived with his roommates at a big house on campus. It was your typical college town party house. There were a lot of roommates and people constantly coming in and out. At that time my priority was to try to make money, and I saw a houseful of rich college kids as the perfect clientele. College kids like weed, so I thought it would be the perfect product to push.

I started growing it in a basement, but I knew it would take some time to actually turn a profit, so I went to my friend Craze, who sold a lot of different kinds of drugs. The one that was most popular among his clientele at that time was crack. I had never

got into crack before, and I wasn't prepared for the kind of customers you get with it. They'll do anything for it. I knew this woman who had started off as just a weekend user, but within a few months of selling to her, she had sold all her furniture and belongings for those drugs. I remember walking into her house and her daughter looking at me with these angry eyes. She hated me for being the one to give it to her. I felt like the worst person in the world, and that look she gave me cut deeper than any stab wound I have ever received.

That look was all it took, and I remembered something my homie Já-Rocc said: "Not all money is good money, J."

I couldn't do it anymore.

Já-Rocc was always really good to me. Unfortunately, he got caught up in a twisted application of the three strikes law. He had turned himself in over a connection he had to an altercation from the early nineties that led to all his homeboys getting locked up except him. At the time he was the only one who didn't get put in. Já-Rocc wanted the record to reflect what had really happened and not what it looked like, so he was willing to turn himself in and take a loss so that his boys had a chance at getting less time.

When he confessed so that he could save his homies, he learned that they had snitched on him for this incident and other crimes. Years later he was remanded into custody, and the two previous

felonies were rolled into those cases from 1992.

The three strikes statute did not even exist during the initial crime, but it didn't matter. Without his knowledge, the infractions were retroactively converted into strikes while he was in custody.

The system chose to turn those two convictions into strikes, which gave him three strikes. It was unjust. He's still locked up right now. The law has since been overturned, but there has been no review of his sentencing. He's not the only one.

There are a lot of people who have unjust sentences across the country, and the way it works in California is that they really don't care.

Prison is big business. Corrections officers, prison consultants, lawyers, the people who privatize the commissary system—they all benefit from how slow the system is to acknowledge its biases and mistakes.

They might sentence you knowing that you can beat the case on appeal because they're aware of how unlikely it is that you'll actually be able to get through the appeals process. They know that they have the advantage because the state's backlog of cases means that it takes ten to fifteen years to get into a federal appellate court.

You have to be denied by California State three times to be able to get to an appellate court on a federal level. During that

time you're appealing to the same state that sentenced you in the first place.

So, obviously, they're not going to be excited to overturn their own sentencing because it could potentially set a precedent that could call into question other cases that are already settled. Now you must be denied three times by the people who sentenced you in order to get to a federal level. For you to possibly come home, it might take ten or fifteen years. By that time most of your family members have given up trying.

Once you're in, it's never easy to get out, but I'm so proud of Já-Rocc for what he's accomplished while in the midst of trying to get out of the system. He's completed several courses, along with ten self-help courses. He earned his associate's degree in social science, and now he's working on his bachelor's degree. All while being locked up. For some people who go to prison, it's easy to give up on it all, but not him. He'll continue to fight and continue to grow.

I started dating this girl I went to grade school with, Tina, and we really hit it off. Nothing in my life has ever been calm, but I would have to say that Tina and I had the calmest relationship I've ever had.

The day I was extradited back to California, Tina and I were

at the general store getting some lures to go fishing. The staff took one look at me, and I was immediately on their radar. I didn't even steal anything, but they assumed I had and called the police. When the cops showed up, I knew if I didn't get away, then I'd be back in jail.

I ran as fast as I could, jumping fences and dipping through yards. If my stupid shoe hadn't slipped off in this woman's yard, I probably would have outrun them. When they got ahold of me, they beat the shit out of me and pepper sprayed me way more than necessary. I had this big Afro at the time, and they used my own damn hair against me by pinning me down with it and spraying me some more.

I was bleeding, was covered in mud from head to toe, and was bright-ass orange from the amount of pepper spray they used.

The elderly Black woman who lived in the house had witnessed the entire thing.

"Baby? Baby? What's your name, baby?" she called out to me.

My first instinct was to apologize to her. I didn't want to involve this nice woman, and now here I was bringing chaos into her yard.

I looked at her and told her I was sorry for disrespecting her yard.

"No, honey. I saw exactly what they did," she replied, coming closer to me. "Honey, that's called police brutality, and it's not okay."

She spoke directly to me with no fear of the police around her. She held her head high, and she stood up for what she believed in. She even went as far as to say that she would be filing a complaint against the police department for excessive force. She kept a close eye on me as they put me into the police vehicle.

I couldn't believe it, and I'll never forget her kindness. She didn't have to say a word. She could have ignored it like so many other people do, but she didn't. She cared. Even though I brought all that mess into her yard, she still cared. She was a genuinely good person, and it was the first time in my life that a stranger had ever stood up for me. It felt good.

Sometimes I did this thing where I told the police that my name was Emery rather than saying my own name. Sometimes I'd get lucky and they'd just let me go, and this time I was hoping that since I didn't actually steal anything from the store, that it'd be all good. But I didn't get lucky. The woman doing the intake was less than pleased when she pulled up my photo and saw through the lie. She pointed at the screen and said, "Hum. Now this looks a little bit more like you." Then she pointed to a previous mug shot with my real name in the headline.

I spent the next eight months in the very disgusting Spokane County Jail. Jails are not like prisons. Some prisons are privately owned and have full commissaries run for profit. You can get

Doritos and Ben & Jerry's ice cream if you're in the right prison. You can send emails, and there are books and magazines to help you forget that you're housed like cattle with people who want to kill you. However, most jails don't have anything beyond the basic food and hygiene products, and they're absolutely miserable.

I was actually relieved when the state of California came and got me. The US marshals arrived to transfer me. I hate the way they transfer inmates. They put this huge brace on my right leg. They strapped me into it and placed several thick padlocks on it. It was all done to lay flat and discreet so as not to make others feel uncomfortable on the flight.

Then they placed chains neatly around my neck and ran a thick metal chain tightly through the belt loops on my jeans before pulling them up for me. To the outside world, it looks like a humane transfer, but in reality you're fighting to even move.

The US marshals were extremely mad that they had to transfer me and made it very clear how they felt. They talked crap the entire time. So much that you'd think the cost of my transfer was coming out of their pocket, not putting money into it.

CHAPTER 8:
XOXO LOVE, MELISSA

I was taken to Tracy State Prison, which was later known as Deuel Vocational Institution, and stayed there for ten days before being transferred to San Quintin. It was in Tracy that my entire life changed.

When I first arrived at the prison, there was a nurse in the hallway. She was tall and beautiful, with straight light-brown hair and the prettiest smile. I later learned her name was Melissa. We locked eyes with each other, and I felt this overwhelming connection with her. I had never experienced that before. Especially not with someone I had never spoken to. I saw her again a couple of days later, and the same thing happened. A lot of inmates will hit on the nurses and throw down some game, but I have no game. I've never had game, but that was a time when I wished I did. I wanted to talk to her so badly, but I knew I would be leaving soon, and it seemed pointless to try.

When you're transferred, every inmate has to go through a medical check, and the following day was mine. I walked out to the area where we waited for the doctor, and I saw Melissa sitting on the nearby benches. She looked at me with those same sparkling brown eyes and smiled. We shared a brief conversation.

I can't remember what we said, but I remember how I felt. Even though I was caged and shackled, I had never felt so comfortable in my life. Her bright spirit lit up my entire world.

A couple of days later, I was cleared for transport to San Quintin, and I did everything I could to get her out of my mind. I didn't think I was ever going to see her again. Just as I was leaving, I caught a glimpse of her standing by the gate, and we shared one last look before she disappeared from view.

Mail time matters more than anything in prison. There are inmates who have been down for years and who have never received a single letter, yet they still show up to mail every single day with a hopeful face.

Everyone wants to believe that they have someone in the outside world who cares enough to put pen to paper for them. Even as the world has changed with email, there's still something about holding a letter in your hand that transports you to someplace beyond your surroundings.

It was mail day, and I was excited when I saw that I had received a letter. This letter was different. It even smelled different. The envelope had this perfect handwriting across it, and all I could smell were flowers. I read the name, and it was from Melissa. I could tell by her words that she was nervous to write to me, but the way she wrote was so kind and genuine.

Within a few months, we had written each other countless letters. I had never had a relationship before where we learned everything about each other before being intimate. It was a completely different dynamic.

Melissa was the most optimistic person I had ever met. She was a dreamer, and she shared those dreams with me. She was a licensed vocational nurse, but she wanted to obtain her RN and eventually her MSN. She was so excited about getting her degree and moving forward.

I loved the way she talked about her children. She didn't speak about them like they were just another responsibility or a duty she had to perform. She truly showed love for her children, and it touched my heart to hear.

She talked about how she wanted to travel the world and the places she would go to. I never allowed myself to think about those things, but she would say them as if it was already a done deal.

She, too, has been through some very difficult times in her life, but she never let it dull her light. We bonded over stories from our childhood, and although we came from different worlds, we understood each other better than I could have ever imagined.

She asked me questions about what I wanted for myself, and I

didn't have great answers. After the first months of writing back and forth, she finally asked what my plan was for when I got out.

I could have easily lied and sold her a dream about all the things I wanted to accomplish when I was released. A lot of inmates make empty promises to get them through the day.

But I didn't want to lie to her. Keeping it real seemed like the best option to solidify this relationship that we were building.

I was honest with her and told her that, at the time, I didn't have a plan. I explained that because my sister had moved, I didn't have any family in California to stay with. My homies were scattered all around, and the halfway house was a death warrant.

I told her I would probably end up running to another state the second they opened the gates.

I didn't care whether the corrections officers were reading the letters.

Melissa wasn't with it. "Please don't do that," she pleaded with me in a letter. She offered to get an apartment for us in whatever city I was mandated to be in while serving out my state parole time.

"Don't go on the run. Let's just get you off parole and then we will see where this thing goes," she wrote. "Who knows what can happen?"

It didn't take much convincing. I knew in my heart that the

second I got out, all I wanted was to be with her.

In my letters, I told her things that I had never told anybody. I shared stories from my childhood and confessed the things I was afraid of. It was a new depth of communication that I was unused to, and I'm not sure that it would have happened if it wasn't in writing.

I was very institutionalized at the time, and so it made it a lot easier to offload through a letter. It was the perfect medium through which to be very honest. You couldn't be distracted by the physical, which led us to connect on a level that I didn't expect.

Melissa also talked about her past relationships. She was completely up front and shared what she thought had gone wrong with her previous partners. She wasn't bitter or vengeful. She was thoughtful about it.

She didn't see her children as burdens. She adored her six-year-old daughter, who lived with her parents in Hawaii, and her two-year-old son.

Five words to change your life: *Who knows what can happen?*

CHAPTER 9:
HOMECOMING

Folsom, California

A part of me thought it was going to be weird when she picked me up from prison. Writing to someone is one thing, but it's an entirely different situation when you're face-to-face and in each other's space. I had built her up in my head for so long, I was afraid that once we were actually together, it wasn't going to feel the same way. I thought I was being naive.

I was wrong. When she picked me up, it was like we'd been around each other a hundred times before. There were no awkward moments or uncomfortable silences. It just flowed.

She rented us a place at the Extended Stay America, and we were there for a month. She even got me all these new clothes and shoes because she knew I came back to Cali with nothing. She really gives her all in everything she does.

I instantly fell in love with her son, Robert, and her daughter. Robert had this incredible spirit and was so curious about the world. I knew I wanted them to be my family. I knew I wanted to protect them, but I soon learned that her loving me could put them in danger. The second they came into my life, they became targets.

A few days after being released, Melissa, Robert, and I were asleep at the new place when the gang task force, fully decked out in SWAT gear, kicked down the door to do a sweep. When you join a gang and are under parole or supervised release, you forfeit your right to privacy, and they're allowed to search your space at any time.

They swarmed the room and threw Melissa and me onto the ground. Two-year-old Robert stood up, terrified, and started screaming as they pointed a rifle right at his face. Handcuffed on the ground, I saw red. He was a child in a Huggies diaper, and they considered him enough of a threat to point a gun at him.

People came in and inspected every inch of the room for contraband. There was none. They did all that and traumatized a little boy for a routine inspection.

I thought for sure this was it, that Melissa was going to leave, and I couldn't blame her, but she didn't. She stuck with me.

A year and a half later, we took a trip to Hawaii where her daughter was living, and that was the first time I got to meet her in person. She has that same bright light that her mom does. A big smile that makes everyone around her smile. They were everything I could have hoped for.

Melissa helped me take the first steps of envisioning a new kind of life for myself. I put a lot of energy into building a

relationship with her children. I wanted them to feel supported and cared for. Her son's dad, Big Robert, was around, but I knew that he wanted to see more of him.

Melissa and I had gotten Little Robert involved in all kinds of sports, and I helped on the coaching staff of his soccer and basketball teams. It was something I took very seriously. I was that proud bonus dad at the game rooting for my guy to give it all he had.

I knew what it was like to feel as if everyone had their dad and you did not. I never wanted Robert to feel that way. Because I was coaching, I thought Robert's dad might feel awkward coming to the games, so I wanted him to know that Little Robert always wanted him there. I called him up, and we had a really good conversation. We had a lot in common and were both trying hard to become better versions of ourselves.

He was always respectful of my relationship with Melissa and never tried to interfere with the family we were trying to build. I returned that courtesy and was always respectful of what he had with Melissa and his relationship with his son.

He started coming to all the games, and before I knew it, we were standing on the sidelines, screaming together. Ever since then, we've never stopped communicating and even built a friendship of our own.

CHAPTER 10: HOMECOMING INTERRUPTED

When you're a known gang member under parole or supervised release, you forfeit your right to privacy and not in the pretending-to-agree-to-the-terms-and-conditions-I-never-even-skimmed way that the average American does when they pick up the latest iPhone from the Verizon store. As far as the state is concerned, you gave away the right to be considered anything other than a gangbanger the second you pledged allegiance to a set. It doesn't matter if you were a kid when you made the decision. When you made that choice, you became an enemy of the state forever.

Whatever you learned about the inalienable rights you're granted by the constitution, if you stuck in school long enough to read that part, no longer applies to you and yours.

After a few stints inside, I understood that I had completely lost my rights. There was a giant Northern Crips tattoo on the front of my neck. Nobody cared whether I had time to slip on a pair of sweatpants before a battering ram was aimed at my door.

What I didn't understand was that when I made that choice for myself, I would be making it for anyone else who would enter

my life too. The second Melissa and her children came into my life, they became targets. They were treated as if they committed every crime that I had right along with me.

On my third day out of prison, I was lying in bed with Melissa and Little Robert. We had spent the day getting to know each other, and we fell asleep talking excitedly about what we wanted the next day to bring.

After nearly two years of monotony, even the tiniest unexpected shift in my day seemed extremely exhilarating. I watched this innocent little boy, and I thought to myself, *I can do this.* I knew in that moment that I could do it. I could be a father to him and his sister.

Robert was sleeping peacefully between us at 5:02 a.m. when the gang task force kicked down the door to the room in full SWAT gear.

One second the room was pitch black, with only the sound of our snores. The next it was full of flashlights and gun barrels. They snatched Melissa and me out of bed, separating and handcuffing us immediately. On the ground with guns to our heads, neither of us could move an inch without that ugly-ass print on the polyester carpet being the last thing we ever saw.

Little Robert stood up, terrified. They pointed a huge assault rifle at him. He was screaming his head off with the gun pointed

directly in his face. I will never forget the fear and shame I felt in that moment.

This was a two-year-old child wrapped in a Huggies diaper. He was clearly not a threat to anyone. He didn't ask to have a mother who was attracted to a felon, but somehow they felt like he deserved to be threatened and manhandled like he had a choice in the matter.

People wearing goggles and helmets inspected every surface, screaming, "All clear!" at one another as they swept the room for contraband. They searched everything in the room. They inspected all the laptops and the TVs, writing down model numbers and running them against the barcodes to make sure nothing was stolen.

According to them, I was at the top of the list for gang sweeps, and so they hit me first. Because I was still on supervised release, I was considered a ward of the state, and they had the right to kick in my door at any time and search anyone who was around me.

It was allegedly random. Theoretically it didn't matter where I was or who I was with at the time. A sweep of my residence, temporary or permanent, could be conducted whenever authorities felt it was necessary.

But magically, later in life no sweeps were ever conducted on

me once I began staying at luxury hotels and spending time with powerful people. I was on parole then, and I got home visits, but no one ever kicked down the doors where I was staying or pointed firearms at the people in my home.

I guess only a cheap room at an extended-stay hotel, a single mother, and a helpless little boy rated cause for concern.

I would not have blamed Melissa if she'd left me right then and there. A lot of women would have. She easily could have written off our connection as a failed experiment that she didn't have the stomach for.

Instead, she gritted her teeth, comforted her child, and moved on with our plans.

CHAPTER 11:
DATE NIGHT

I will never forget one of our first date nights as a married couple. The local bowling alley had a drink special called Adios Motherf*#ers. I don't know what it is about that drink, but every time I have one, I end up in jail.

Melissa doesn't drink often, so when she does, it hits her pretty hard. We were on our way home, and in her hyperactive, drunken state of mind, she popped me on the side of the cheek. I had a cigarette between my lips, and it fell right out of my mouth, so I stopped in the middle of the road to grab it, and a cop happened to see me.

I got pulled over, and the officer approached the vehicle. I explained that I was trying to get my wife home and that yes, I had been drinking.

If you get arrested while you're on parole, your parole officer has to sign documents before you're able to be released, so I knew I wasn't going home that night.

The cop put me in the squad car, and we talked on the way to the jail. When he said I'd be out that night, I laughed. I said there was no way I'd be able to get out until my PO came in.

After I was processed, I was shocked when I heard them call

my name to be released.

As I walked across the dark parking lot, I saw the cop sitting in the patrol car, and I heard, "Told you you'd be out tonight!"

That was the nicest any cop had ever been to me. If they all had kindness and decency like that officer, there would be a lot less death on the streets. Unfortunately, even the good ones turn a blind eye and keep silent when they see their fellow officers using excessive force. You always see that one, standing off to the side with this look on their face. They know what's happening is wrong, but fear of going against police code stops them from standing up for what's right.

After that, you'd think we would have learned our lesson about Adios Motherf*#kers, but on another date night, here we were again. We were having the time of our lives, dancing to the music and trying to convince the DJ to play all our favorite songs. I should have known the curse of that damn drink would come back to bite me in the ass.

It was when Melissa missed the chair and fell on her butt that I knew it was time for us to leave. As we were walking out, cops pulled up and immediately started harassing us. One cop asked her if she knew me and was treating me like I was kidnapping her or something.

He kept yelling, "Do you know him? Do you really know him?"

Mind you, Melissa was very drunk.

She was mumbling yes, and I was pointing at our rings, saying, "She's my wife! We're married!"

She was trying to stand up straight when they started manhandling her. They aggressively wrapped her arms behind her back and slammed her, face-first, into the concrete. When I saw her eyes roll back into her head, I lost it. I punched out two cops before they slammed me to the ground. They beat the ever-living shit out of me while Melissa was pinned to the ground by my side.

As the group of them were kicking me, the one detaining Melissa was in her ear, calling her a nigger lover and criticizing her choice in men. They threw us in separate cops cars and continued spouting off their racist remarks.

When we arrived at the jail, they left me sitting in the car. I saw the officers gather in the dark by the corner of the building. They were silent and looking over at me. I knew exactly what they were doing. They were planning to beat the shit out of me again.

I start yelling, "I know exactly what y'all are doing over there! Why wait? You wanna beat on me some more? Go ahead and do it then! Might as well get it over with!"

They immediately came to the car, grabbed my legs, and yanked me out. I felt the sole of a shoe and the weight of an

officer's body on the back of my neck. He stepped down even harder when he heard my muffled screams. I felt every kick, every punch, every bone in my spine as they stomped on my back. They took my face and rubbed it into the gravel like they were grating cheese.

As my flesh was tearing from my face, one of the cops said, "Yeah, you're a pretty motherfucker, aren't you? Well, you're not so pretty now, huh?"

Then, after all that, they threw a spit guard over my entire head. A spit guard is a thick mesh bag that they place over someone's face when they're spitting. As soon as they put the bag over my face, one of the officers put his hand over my mouth and nose and started suffocating me. I did everything I could to signal to them to stop, but they would not. As I fought to take a breath, I felt everything go dark. Time slowed down, and I truly thought I was going to die.

I thought, *This is it. I'm never going to see my family again.*

I don't think any words can describe what it feels like to believe that you're going to die. Even now, I experience this overwhelming pain just talking about it.

When I came to, they were dragging me into the drunk tank after the first beatdown, twisting me up like a pretzel as they stomped me before they slid me under the bunk and took my

cuffs off. It was a small cell, but they crammed in to get a few more licks before they bolted like they thought I had it in me to get up and chase them, but I had nothing left. I just laid on the floor, broken, in piss and vomit, grateful and amazed that I had survived.

It was a coed facility, and after Melissa and I were processed, they put us in the same waiting area. When they dragged me out, Melissa was already there. She dropped to the floor when she saw what they had done to me. I was unrecognizable.

They finally released us both. They obviously couldn't charge Melissa with anything, but they made sure to hit me with an obstruction of justice charge.

When we got home, it broke our children's hearts to see what they had done to us. Do you know how messed up it is to have to explain to your kids that the police did this to you and that you never did anything wrong? A child should never have to fear that their parents are gonna be murdered on a date night.

I didn't know it at the time, but this moment was the catalyst that sparked my desire to be an advocate for others like me. To speak up on behalf of those who have experienced the same kind of pain and to do what I can to try to stop it from continuing to happen.

CHAPTER 12:
HARD IN DA PAINT

A little while after we were married, Melissa found out that she was pregnant. She took seven pregnancy tests, and they were all positive. I was so happy to be a father that I kept several of the tests as memorabilia, but a part of me was also worried that I wouldn't be a good one.

We were living in a big house in Weston Ranch, Stockton, at the time, and it was the first place we really made feel like a home.

During that time, my mom really stepped up to the plate. She had moved all the way from Minnesota to live with us so that she could help with the kids.

She and Melissa decorated the nursery together and painted it baby blue. They picked out all these cute little baby outfits, and they made sure everything was perfect and all set for our baby's arrival. My mom was even able to be in the room with us when Melissa gave birth.

The day had finally come when Melissa's water broke, and I knew everything was about to change.

I was standing next to Melissa's side and holding her hand. I stayed as close as I could to her. I wanted to witness every detail. There are so many fathers who aren't able to meet their children

when they come into the world. They sit in boxes and pray that they'll make it to the day when they can hold their baby in their arms. It wasn't enough for me to just be in the room. I wanted to see him the second he entered the world.

I reached out for him before the doctor could give him to Melissa. I had my shirt off, and we had skin-to-skin contact. I connected with my amazing little baby for what felt like an hour before handing him over to Melissa. Our bond was imprinted right then and there. He was so pure and innocent. I almost couldn't believe he was real. From the moment I looked into his eyes, I had something so special to live for. His name is Jeremy Jr., but to me, he's my little Bear.

After Bear was born, my mom was there every day, waking up with Melissa and me and helping us take care of both Bear and Robert. She lived with us for several years and was so helpful. She would help the kids with their homework and take them to school. She loved baking and was always teaching them how to cook. I am so grateful for her. I know that she wasn't able to be the mom she wanted to when we were kids, but she has grown into the most wonderful mother and grandmother.

I couldn't ask for better, and I'm just so damn proud of her and everything she has overcome. One of my favorite things to do was to hold little Bear in my arms and then listen to my mom tell

stories about when I was his age. Having my son really reactivated this bond between my mom and me. It brought us closer than ever, and after not having a relationship with her for so long, I felt so absolutely blessed that she was there during such a pivotal point in my life.

Watching Bear grow is like a dream come true. I may have been nervous and scared to be a father given my past—from childhood to prison—but when I held him in my arms, it was like my soul instantly knew his. Like we had been together for lifetimes already. I was so amazed by how smart he was and how he was able to pick things up so quickly. I couldn't believe that this perfect little human being had come from me.

Becoming a father is the best thing that has ever happened to me. It changed me. It used to blow my mind when I would sit there for hours and watch Bear mimic me in real time. Watching him copy everything I did had a powerful impact on me. It reinforced the burgeoning idea inside me that what I did mattered. I knew that he was going to follow my lead and that it was my responsibility to set a good example.

CHAPTER 13:
THE CAPE COMES OFF

After becoming a father, I started contemplating my relationship with my own father. I had so much hate for him because of the things he had done, but as a person, I didn't know him at all. I wanted to know him. I wanted to see for myself.

I've spent a lot of time in penitentiaries. I've slept in them, bathed in them, and cried in them. My blood has coated their walls. My sweat has soaked into their floors. I even met the mother of my child there, but I am not a penitentiary man. My father, on the other hand, was.

When I first applied to be added to my father's approved visitor list at Washington State Penitentiary, part of me thought it wouldn't happen. When I got that approval notice, it made everything real. I was torn because I didn't want to tell my family I would be going to see him, but I didn't want to turn down the chance either.

During his time at Washington State, my father had stabbed a member of the Aryan Brotherhood.

The Pacific Northwest might be depicted by the media as a liberal paradise, but it's actually a stronghold of White supremacy both inside and outside the prison walls. The prison, known to

locals as Walla Walla, was filled with hateful people who thought they were better than any person of color, and they would have loved to prove their loyalty by ending their lives.

Several corrections officers learned of a plot to kill my dad and shipped him from Washington State to Minnesota for his protection.

When he returned, I thought this might be my only opportunity to be face-to-face with the man who made me.

I booked the ticket and came back to Washington.

Conflict and confusion washed over me as I entered the visitors room. Everything felt unnatural to me. I had never been inside a prison facility unless I was an inmate.

Being seated next to anxious family members instead of a brooding corrections officer was odd. I shifted in my seat as children bickered with their siblings and women fidgeted anxiously. Everything felt like noise I couldn't cut through. The fluorescent lights, the stale perfume, and the creaky strollers all suffocated me.

There was an inner battle inside me. As much as I wanted to hug my father, I also wanted to take his life for all the pain he had caused.

When he entered the room, I recognized him immediately. His presence was enormous, and it was almost like he was

walking in slow motion.

He apologized for the effect that his choices had on my life, but I knew from his demeanor that it wasn't genuine. He was sixty years old, getting caught up in stabbings and still messing with cocaine and heroin on the inside.

After three decades behind bars, nothing had changed. It was the first time he had ever heard his youngest child speak, and he nonchalantly asked if I thought to bring some drugs in for him. Then he started spitting out facts about my life like he knew me.

I left that visit angry.

Little did I know, two weeks later my entire life would change.

I have to be honest, I had a few ups and downs and some hiccups along the way. I know I wasn't perfect and that I did things I'm not proud of, but one of my most fulfilling moments was my first legal job. I worked driving forklifts for a company called Pollution Solutions Incorporated (PSI) in Lodi, California. It was about a twenty-minute commute from where we were living in Stockton at the time.

I had heard that they were hiring through a staffing agency in the area that helped provide job opportunities to people with records. So I got my forklift license a couple of months before I got the job.

It was a contracted position with no job security or benefits,

but it was a chance to make an honest living. It was the first legal job that I had ever had, besides mowing lawns when I was a teenager. It felt good not to have to hide myself to gain employment. Today, after looking back at who I was and what I did, I understand that I covered myself with tattoos to reject the world before it could reject me.

PSI helped me prove to myself that I could be good at something normal. I was back in a warehouse, but instead of breaking windows, I was building up my confidence in my skill set outside of the streets. All I needed was for someone to take a chance on me.

I quickly excelled at the job. After only a few months there, they had me teaching new hires how to best complete their tasks. The warehouse owner was named Pete, and he was a cool guy. He came from old money, and his family had been in the transport business for generations. He judged everyone on merit and cared only about whether you got the job done.

He was the first businessman who ever saw me for me. He looked beyond the teardrops and the tattoos that caused other people to turn away.

I was even able to put a few of the homies on who were also looking to make a positive change in their lives. I was proud that the same people who were at my side when I was causing havoc

in my life by committing crimes were down to work together to do something that was going to make our families better.

I remember the day Pete called me into the office and told me that I was going to be hired on as a full-time permanent employee.

"We're making you a shift supervisor," he explained.

The position was more than just a title change. It came with a four-dollar-an-hour raise. He even let me pick my own crew, so I was able to help more of my little homies looking for a safe way to put some money in their pockets.

Pete had been observing me for a while. He saw how others would listen when I spoke, and he thought that I would make an effective team leader. It felt really good.

When I was able to handpick my crew, I went through the list of all my boys and selected the ones I thought were the best and hardest workers. I wanted to show Pete that we could all do amazing work and that they all deserved to be there.

I built this great team, and it was so much fun and so fulfilling to be able to work with them every day. We got every bit of work done each night. We used to have rubber band wars and would shoot hundreds of them across the warehouse. It was little things like that that made it so enjoyable to go to work.

I remember a very proud moment when my homie Terry got his very first paycheck. I still have the picture of him holding it in

the air. To see the tears well up in his eyes from the accomplishment of holding up his hard-earned money was such a powerful moment for me.

He had made money in the streets, good money at times, but it was all fast money—it comes fast and it goes fast. But he worked really hard for that check. He put in the time, the effort, and the sweat, and he was so proud that he earned that money, and I was so proud of him. From the moment I met Terry, it was like looking into a mirror. We were so much alike, and we instantly became brothers. That's how powerful this bond was. Almost like we were brothers in a past life.

Melissa and I actually took Terry and a few of my other boys to Hawaii once. None of them had ever been on a plane before, let alone to an island. It was amazing to be able to travel to that beautiful place and make those memories.

CHAPTER 14:
PRISON BAE, HOT FELON, AND THE BLUE-EYED BANDIT

Stockton, California, June 2014

The Drug Enforcement Agency (DEA), the Bureau of Alcohol, Tobacco, Firearms, and Explosives (ATF), the San Joaquin County Sheriff's SWAT team, the Lodi Police Department's SWAT team, the Manteca Police Department, the Lodi Police Department, the county-wide Metro Narcotics Unit, and several Stockton gang task force elements collaborated to form a task force called Operation Ceasefire. They served eleven warrants at once and began kicking in doors in Stockton as early as six in the morning.

It was a dark time in the city. It had gone bankrupt in July 2012.

There were no ambulances or EMS services. The Stockton Police Department didn't have any money to pay overtime, leaving the streets open and clean.

Neighboring towns in the county donated services to offset the mayhem, but they were no match for the gaps in the budget.

People could cruise past the Highway Patrol because they could only have a presence in the city for so long until they had to

return to patrolling the highway. It was no wonder that the feds were eventually called to intervene in the chaos.

I was on my way to work with my boy Terry when they pulled us over. They searched the car and found a handgun locked in the trunk. Being a felon, I can never be in possession of a firearm, so I was immediately arrested.

What I thought was a routine traffic stop ended up being part of a bigger plan. They went to my house, kicked down my door, and came up with nothing. It didn't matter, though. There was a gun in the car I was driving, and it was enough to land me right back in jail.

I was devastated. I couldn't imagine going a day without seeing my family. I thought about how Bear was going to feel without his dad, and I hated myself for being in that position. He's my little man, my best friend, my little buddy, and my junior. He had never been without me.

I thought about all the days we spent together and all the days I was going to miss. It shattered me.

When the Stockton Police Department posted my photo on their Facebook page, I'm sure they weren't expecting their actions to make me famous.

I'm so grateful for the opportunities and the doors that it

opened, but I don't think people realized that I wasn't in a position to feel particularly happy at that moment.

CHAPTER 15:
CAGED STARDOM

Mendota, California, February 2015

As I sat handcuffed in the police station, every minute it dawned on me more and more that my son was going to find out that I'd been arrested. All those other times before, I hadn't been a father. Now I was. And all I could think was that I wasn't going to be able to pick up my son from school. What was I thinking about when the Stockton police took that life-changing photograph? I was thinking about my kids. I was thinking about Jeremy Jr. and Little Robert and about the things I was going to miss, like taking them to soccer practice. To have stayed out of prison for nearly seven years, I just couldn't believe that I was going back. That's what you're seeing in my eyes in that photograph. You're seeing my soul laid bare. You're seeing my grief exposed.

I couldn't eat. I was broken. I didn't sleep that night. In the morning, they came hammering on my door. Channel 12 News wanted to interview me. Door seven. I went in expecting to see Channel 12, but one of my homies, Ken, was in there, and he said, "Bro, do you realize you just went viral? Every single news station across the world is talking about you right now. In China, Puerto Rico, London. Your mug shot—the whole world is talking about

it." I didn't even know what viral meant back then.

When I was heading back to the cell, I looked up, and every TV had a picture of me on it. It was the most humbling, scary, exciting, overwhelming experience. I just didn't know how to feel. I knew I was about to go to prison. I was stressed. And there I was, all over the TV.

I got back in my cell and looked out through the little window in the door, tripping, because we can't hear a word. All we can see are all these pictures, including family pictures, and they're everywhere.

So, of course, Channel 12 wanted to talk about gangs and guns, and they were trying to portray me as a kingpin, a drug lord, the shot caller for the Crips, and none of it made sense. It wasn't me. So I told them I didn't want to talk about it. If they wanted to talk about the positive stuff I was doing, perfect, but otherwise, nothing. After, when they were breaking down the cameras and stuff, the guy asked me why I had the gun. I figured it was off the record, so I told him that I had it for protection, because I was at that age when I wasn't all the way out. I wasn't hunting, but if someone ran up on me, I had it for protection. What I didn't know was that the cameras were recording the whole time, and they didn't use any of the positive stuff we talked about; they used only the back end, that bit about the gun that

they secretly recorded.

That was my first real understanding of how the press works, how it manipulates things. They're crafty.

My cellmate, Ryder, helped me grasp onto the privilege of dreaming. There was a lot of stuff coming in, contracts, things that would be life changing. There were bags and bags of letters. Four hundred, five hundred letters, from all over the world, every night. So much mail I couldn't read it all. We would stay up after lights out and talk all night about what my new life would be like after I got home. I didn't know how I would get there, but I did see myself walking in European fashion shows and engaging with international supermodels. Ryder saw even bigger things for me than I imaged for myself. One night while we were sneaking makeshift joints and crafting one of our favorite prison meals, he predicted that I would be more than a model. He saw me on movie screens. He spoke with the same clarity and assurance that the pastor in Florida did.

For the first couple of months, I saved all the contracts. I didn't sign anything. I didn't throw anything away. Trying to read a contract when you've never seen one in your life is like trying to read French. Impossible. It was overwhelming and exciting, sure, but it was also incredibly sad because all through this, my wife

and kids were coming to visit me, and I was forced to see them through glass. But I didn't want to be that kind of father, the one who cuts their kids off because he doesn't want them to see him like that.

"You're going to be in movies," Ryder said. I couldn't even fathom what he was saying then. His vision was beyond what I thought I could accomplish from a picture going viral at the time. But the longer I spent considering my options, the more likely it seemed that I could permanently alter the trajectory of my life. Before the case that sent me to federal prison was fully adjudicated, I was sent to the Sacramento County Jail. It was a state facility, and the guards were good, decent people. The same couldn't be said for the federal corrections officers, who were overly aggressive and were subject to a number of lawsuits as a result of their treatment of inmates. They didn't appreciate all the press that I received. They instructed me not to speak in court. They snatched me up very aggressively. Inmates have had their backs broken and have suffered other life-altering injuries due to their excessive violence.

I never received the same level of hate from my fellow inmates as I did from those federal corrections officers. It didn't matter what the beef was; it never rose to the level of hate they were on. It was constant vitriol. California has one of the most

aggressive police forces in the nation, and they took my popularity personally.

Their hatred manifested itself in bruises on my body on a regular basis. They pulled me out of my cell and twisted my arms behind my back for extreme amounts of time. If I would look at one of them wrong, they would press me up against the wall to the point where I felt like my ribs would splinter. When the corrections officers were transferring me, there is actually footage of them slamming me into the wall.

It wasn't enough to attack me physically; they tried to break me down mentally as well.

Getting involved in a gang has brought me a lot of trouble, but it has also brought me a lot of solace. While I was dealing with the downside of going viral, my homies were grilling me to ensure that I was embracing this chance to do something better with my life. They were hacking into my mind and checking to see what type of time I was on. Recidivism rates for all inmates are in the double digits, but when it comes to confirmed gang members, they're even higher, and they know that. The people inside are aware of what is waiting for them in a world designed for them to fail at any attempts they make to do right.

They wanted to know if was I going to take advantage of this

blessing that was brought to me or if was I going screw it up and keep doing the same shit that brought me in there in the first place.

They had a huge impact on me, and I started to change my thinking about what I was going through. Yes, I was facing the threat of taking a beating on a near daily basis, but it wouldn't always be like that, so I needed to start thinking beyond what was happening right now.

My homies gained nothing from doing this. Some of them had no dates and are still sitting in boxes right now. They just didn't want to see me waste an opportunity to change my life for good. You can be what the world sees as nothing more than a criminal and still be capable of doing something completely selfless. They helped me envision a world beyond the senseless beatings I was enduring.

After a while I opened up to what could happen if this was real.

I started to dream.

Yes, it was true that I had made mistakes. Yes, I had experienced unthinkable trauma. But that didn't have to be the only truth in my life. There could be another version of the truth, maybe even multiple versions, with one of them ending with me on a screen.

CHAPTER 16:
VULNERABILITY

When I first got out of prison and was taking acting classes, Melissa and I went together. The acting coach had told us that he was really into astrology and reading people's numerology. Melissa was interested in finding out what her astrology read.

One day we stayed back after class, and he asked her where she was born, the date, and the time. He entered all this into a computer, and as he stared at this crazy-looking chart, he kept poking his head up from behind the screen and staring at us funny. After about two minutes of this, he pretty much predicted, word for word, what was going to happen between Melissa and me.

He said that my career was going to drive her crazy, that it would cause a lot of fighting and stress between us, that I would end up leaving, and that I would meet another woman and have a baby with her. Understandably, Melissa was pissed when he told her that.

I was thinking, *No way.* You can't trust some computer-generated chart, but as it started to unfold before me, I thought to myself, *Damn, that dude was right.*

The first time I went to acting class without Melissa, Jim

Jordan, my manager, came with me. It was an improv night. Improv is the most hilarious thing I've ever seen, and it's so much fun to do.

At the end of class that day, Max Decker, the coach, introduced me to a new exercise called vulnerability.

For the exercise, you sit across from another person and envision the person who has hurt you the most. Then you ask them why. The whole point is to try to tap into your emotions and to figure out the why. Essentially it's trying to tap into your triggers so that it can activate those emotions inside you.

Jim sat across from me, and I told him that I was going to envision my father.

It took me a bit, but I finally mustered up the courage to get in front of the class and try the exercise. When we first sat down, I started talking and asking him questions like he was my father.

I asked him, "Why?"

Then I asked, "Were we not good enough for you to do right?"

"How could you commit such a horrific crime?"

"How could you let me go my entire life without a father? Having a father was the one thing I always wanted in my life but could never have."

I just kept going and going. I lost myself in that exercise, and

I spoke to Jim like he truly was my dad.

The exercise moved me into an intense emotional state. Then I heard the sound of the other students crying, and it snapped me out of the moment. I got up and excused myself from the room and went outside.

I remember there were so many cars flying down the street as I stood on the sidewalk, overwhelmed with emotion.

A bunch of students came out and surrounded me. They started hugging me and telling me how powerful it was and that I was going to be an incredible actor from how I was able to connect with those emotions. They felt every word that I was asking in that exercise.

Since then, I have forever remained vulnerable. For so long I spent so much time and energy building up this wall to protect myself because I had been hurt so much. I never allowed myself to be vulnerable around anyone, but after one exercise in an acting class in Studio City with Max Decker, I had this breakthrough that changed everything.

Being vulnerable is a gift. It's a damn superpower that I cherish. I could never have had that without Max Decker and his vulnerability exercise, and it's made me a better actor.

CHAPTER 17:
SHOT CLOCK

Mendota, California, March 8, 2016

I didn't leave prison fully understanding the magnitude of what it meant to go viral. I'd never really paid attention to social media trends, and I for damn sure wasn't flipping through the tabloids while I was immersed in the streets. I had no idea what celebrities were doing in their spare time, and I didn't know what an influencer was. The Myspace page that was set up for me by my niece and nephew was the only experience I'd ever had with social media.

For all I knew, my fifteen minutes of fame might have been over by the time I walked out of the penitentiary gates. I think people expected me to disappear after the heat from the picture fizzled out, and a tiny part of me thought that was a possibility too. I hadn't fully accepted that truth of my life.

I am thankful every day that I managed to turn a moment into momentum.

I signed with White Cross Management, an agency owned by Jim Jordan, while I was inside. We started working together as soon as I was released from transitional housing.

The judge presiding over my case was a godsend. Judge Troy

L. Nunley was the only Black judge in the Eastern District. He was interested in the kind of restorative judgment and rehabilitation that can change lives permanently. I was supposed to receive double the amount of time that I got, but he looked at where I was before being arrested and the opportunities I had waiting for me when I got out. He didn't want me to lose them. Instead, he gave me only twenty-seven months because he wanted me to get out and take full advantage of these opportunities.

Twenty-seven months in prison is still twenty-seven months of watching your back. It's twenty-seven months of people trying to harm you day and night.

There were always fights and riots. I knew how dangerous it was to be unprotected. I actually got more time while I was in because I got caught with a knife, but there was no way I would have survived without a means of protecting myself. I was determined to make it out of there alive.

I remember being incarcerated at Corcoran State Prison, where the guards encouraged inmates to fight to the death like ancient Roman gladiators.

The scandal was so huge that it was turned into a 2008 movie called *Felon*.

The code that cops follow is deep and solid. I didn't trust

them to keep me safe. I felt quite the opposite under their supervision.

When I got out, I signed some of those contracts that had come in. I did a whole bunch of pictorial photo shoots and some magazine covers. Despite what the public may think, you don't get paid for those because they're editorials done on spec. No matter how long it took to book a paid engagement, I remained committed to staying on the right side of the law.

My first paid gig was a fashion show for German designer Philipp Plein at New York Fashion Week. The look I rocked in the show was the kind of futuristic getup I had envisioned when I watched *The Matrix*. I wore a $9,000 fur-trimmed leather jacket.

I made $10,000 legally and honestly on that runway. I did it being myself. I didn't pretend that my past didn't exist. Instead, I embraced it.

I was asked to do part of the show shirtless. The stylist selecting and approving the looks displayed for presentation was the famed Carine Roitfeld, former fashion editor from Vogue Paris, known for her impressive eye. She inspected every detail of the looks she sent out for that show. She didn't ask the makeup artists to cover the tattoos lining my neck, forearms, and torso. I felt as accepted at that moment as I had when I was driving a

forklift at the warehouse. My tattoos told my story of strife and redemption to the press and to the fashion world.

Another deal I signed back then was huge—genuinely life-changingly huge. It should have been, at least. The deal was for $15 million to develop my own brand within the fashion industry, with a focus on sustainable materials and environmentally friendly clothing. Appearances can be deceiving, as they say. The truth of the matter is that they paid me for a year and then breached the agreement, so I've been free to do other deals since then.

My manager at the time knew how serious I was and started setting up appearances for me after each show to help maximize my earning potential. I would do the fashion show, then we would head over to the after-party, where I would do an appearance at a nightclub. Sometimes I would get paid more to do an appearance than I did for walking in a show. We were doing meet and greets and photo ops all over.

My judge helped make this possible. He knew that I was being given the chance to travel the world for work, and he didn't want to hinder my opportunity to secure and maintain work that would prevent me from returning to prison.

When you're on federal parole, if you want to leave the country, you must set up a court date where you can request

permission to leave their jurisdiction. You have to wait for that court date to come up and then get in front of the judge to find out their decision. If the judge isn't there, or if that court date is canceled due to something like an emergency, a national holiday, or bad weather, you're out of luck because you can be remanded into federal custody for trying to get on a plane.

If you want to leave the state, your parole officer can let you travel anywhere within the United States, but they cannot override the authority that is given to the judge.

Before I even got out of prison, the judge on my case had already filled out the papers that I would need to have in my possession to be able to travel the world. I didn't have to wait months or weeks to get on a court docket. I didn't have to take time away from practicing my new skill set to request it.

I came home to papers stating that my parole officer had free rein to let me travel to anywhere in the world that he saw fit. He not only signed the papers for me to be able to travel wherever I needed to go but also let me off parole early. The court had initially sentenced me to three years of parole, but he let me off in less than two.

This was a huge asset in starting my career. When someone reached out about booking me, I didn't have to take my time getting back them or hit them with a vague response like *maybe*

or *hopefully*. I could confidently confirm that I was capable of showing up and doing what was required of me.

I showed up time and time again. The appearances became the bulk of my job.

We did them in Germany. We did them in Switzerland. We did them in Dubai. They initially booked me because people thought I was attractive, but it was my job to make sure the phone kept ringing.

I was intentional about bringing good energy to every runway, photoshoot set, nightclub, and coffee shop that I entered. After all I had been through, I knew how lucky I was to be hustling selfie opportunities for a living. I treated the cameraman like I treated the billionaire. I treated the waiter like I treated the businessman because I knew that they were fundamentally the same.

I addressed everyone with kindness and respect, and I introduced myself to everyone. I never assumed that they knew who I was, even if they were part of the team that booked me.

There are a lot people out there who walk into a place and are deliberately rude to those who they see as less than. I don't ever want to be that guy. What I put out, I know that I'll get back, and so I try to project my energy at all costs and make sure that others feel good when they leave our interactions.

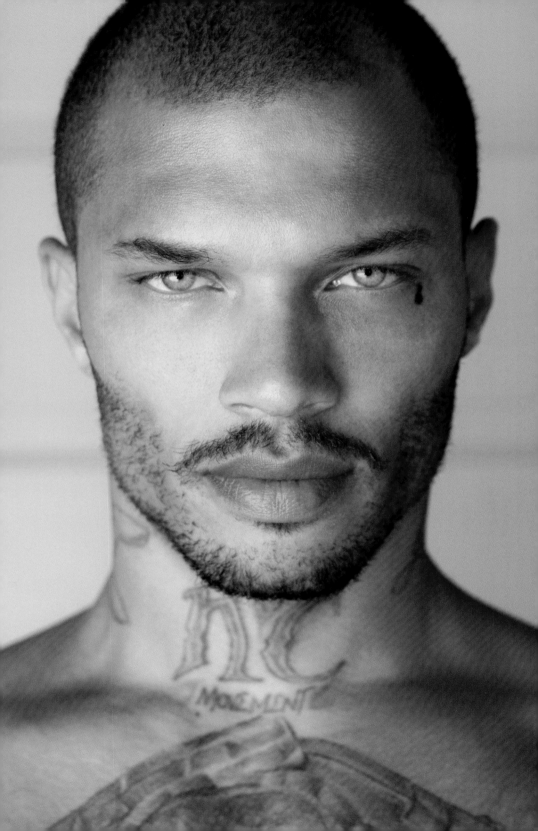

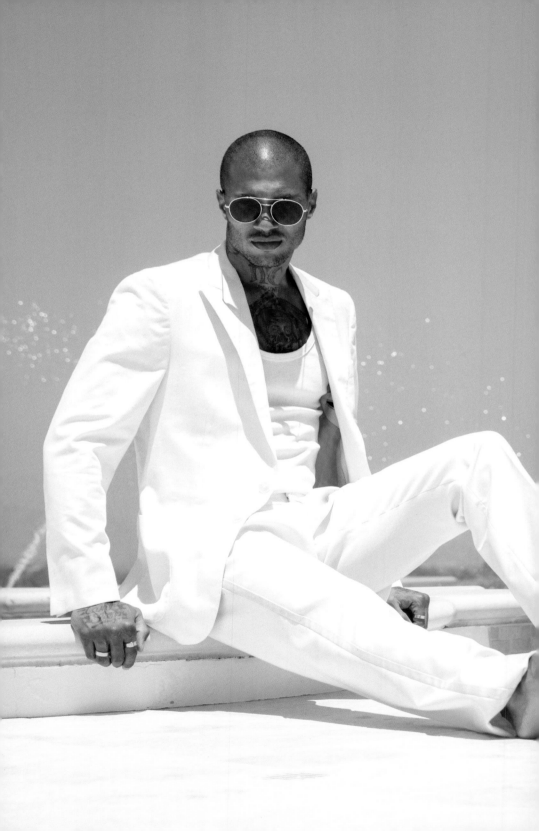

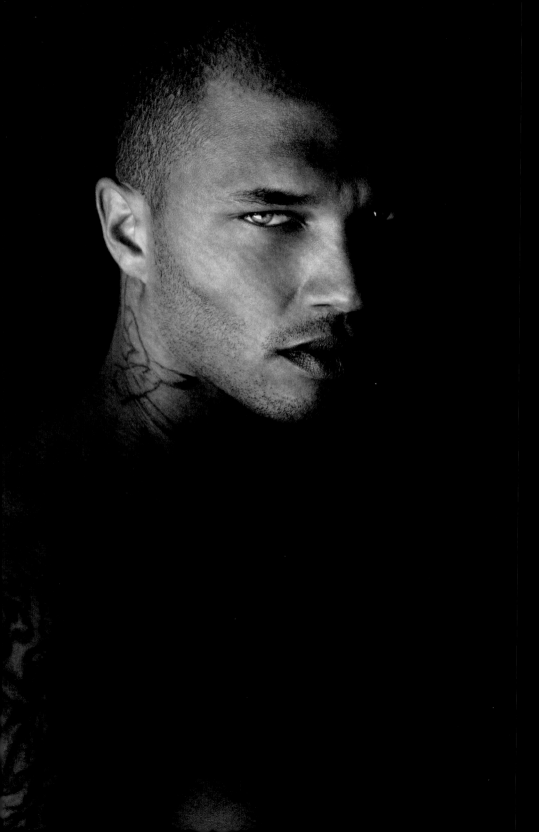

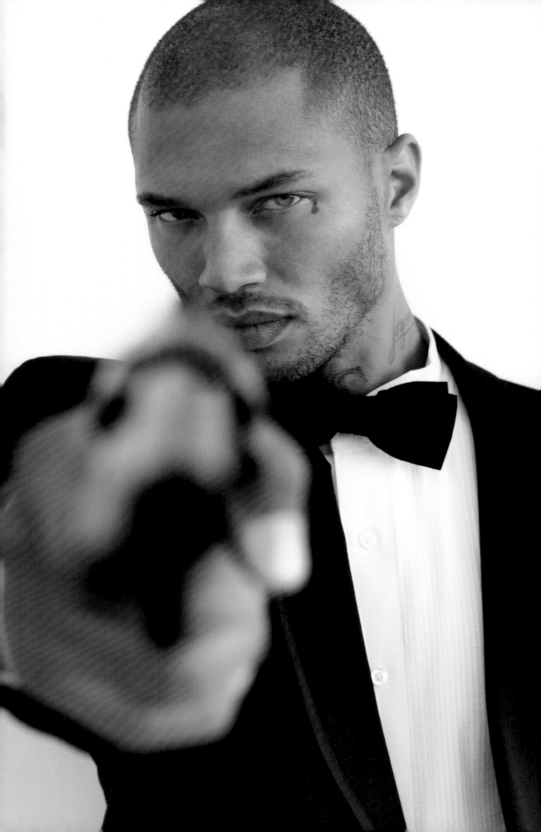

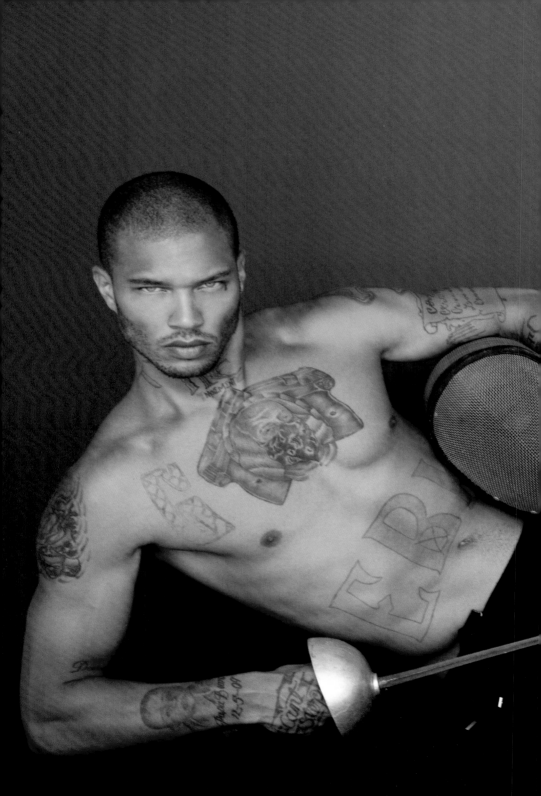

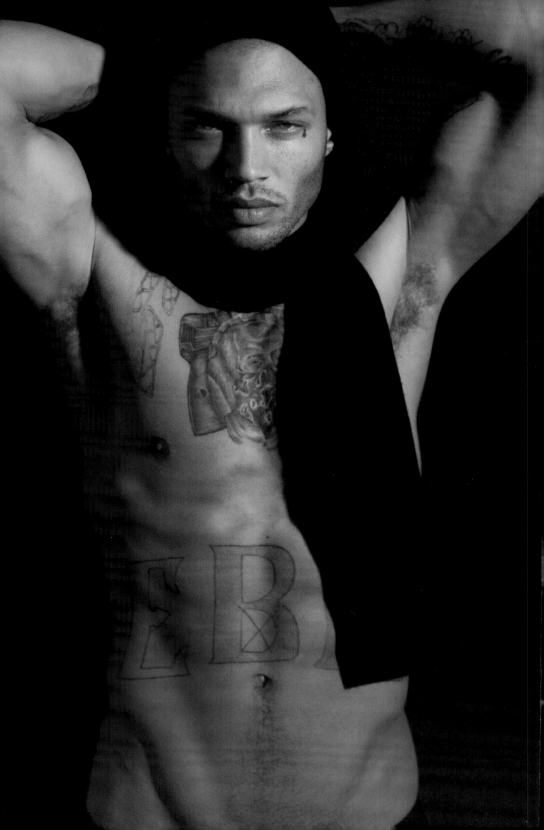

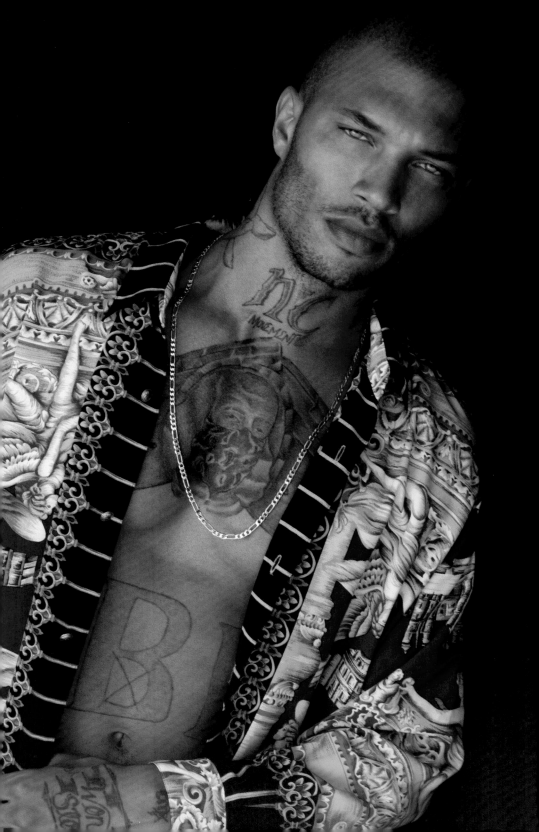

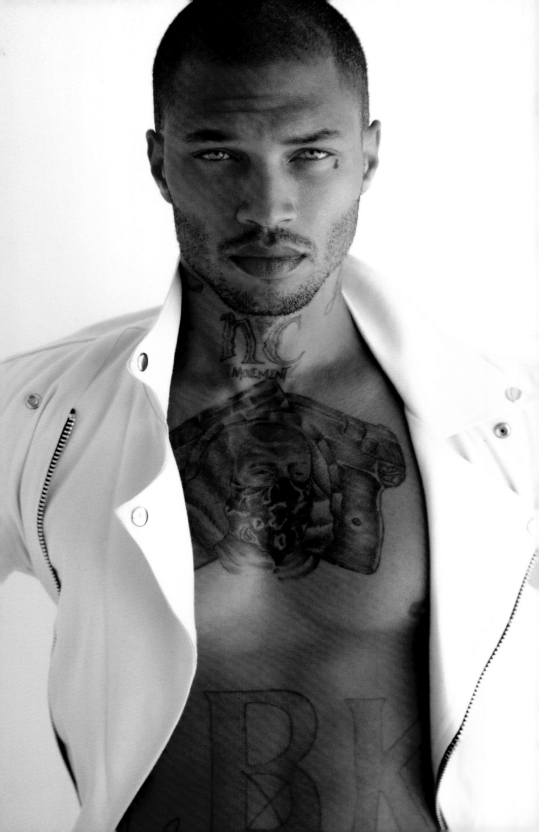

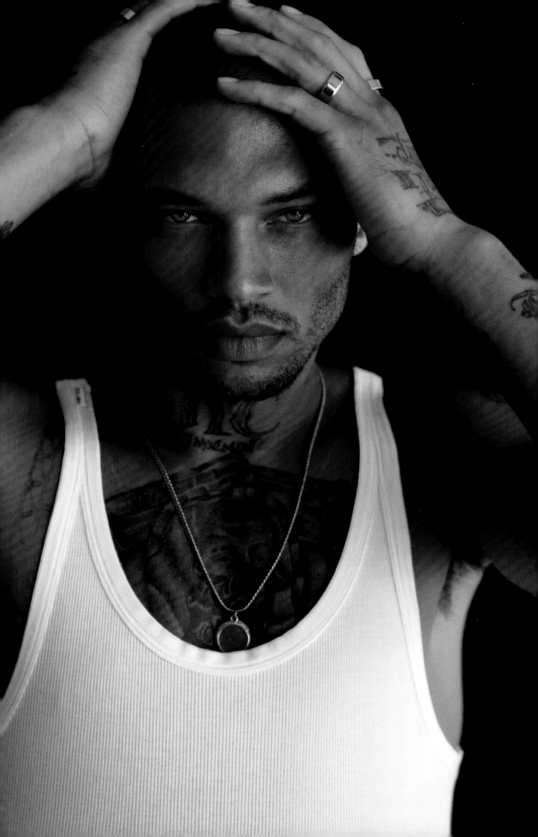

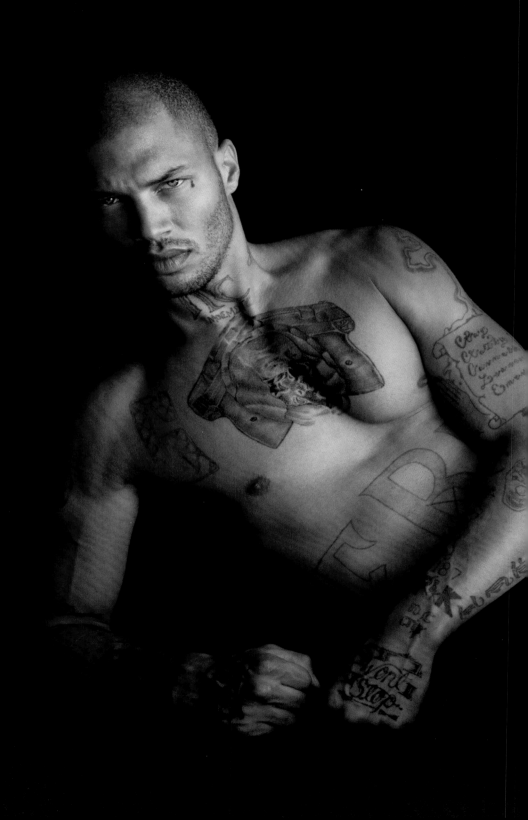

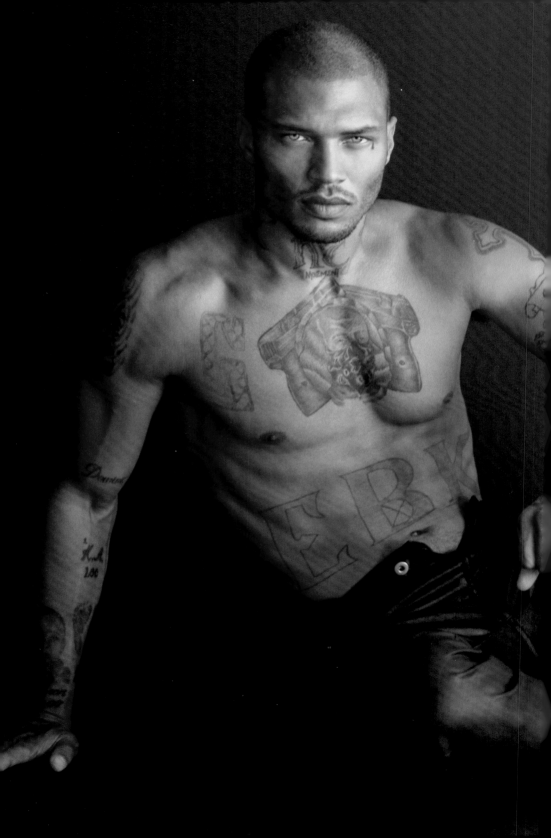

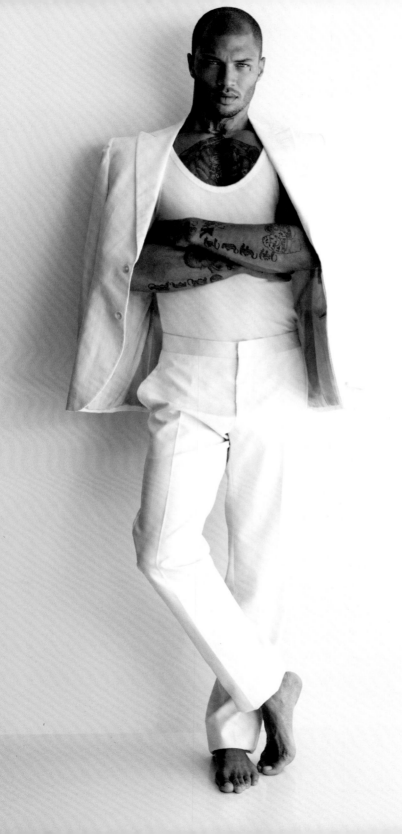

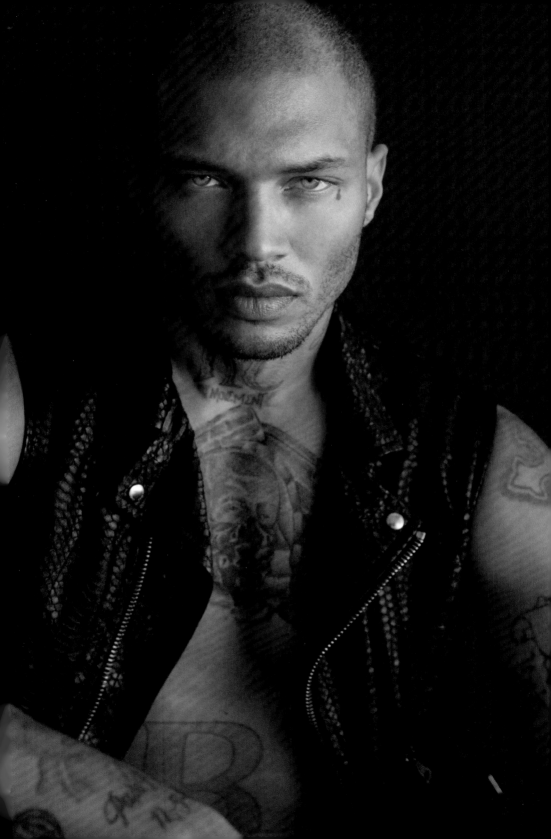

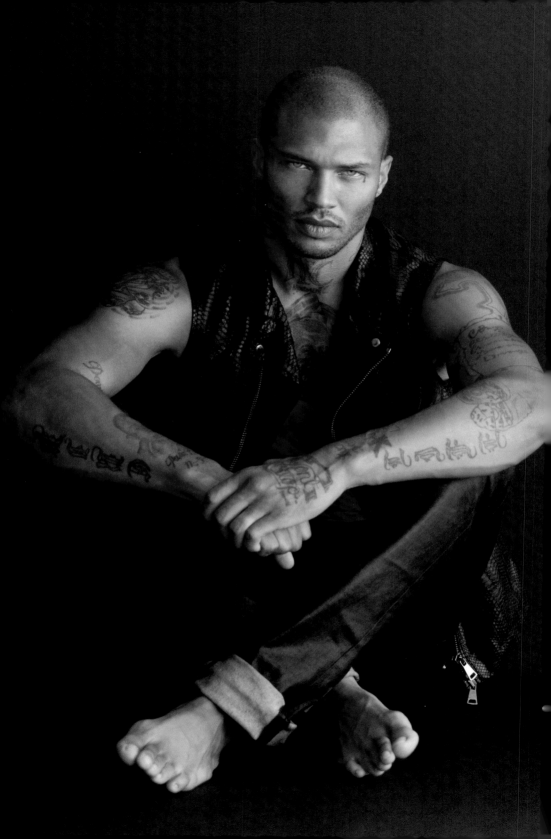

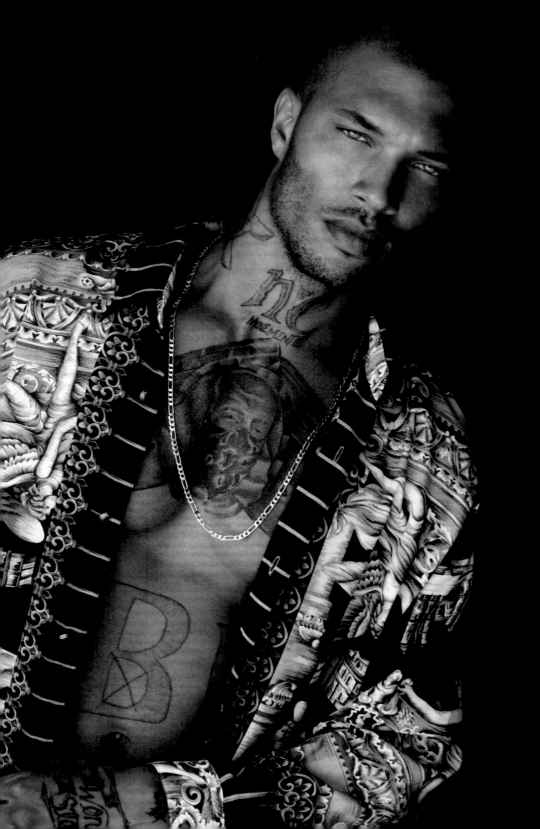

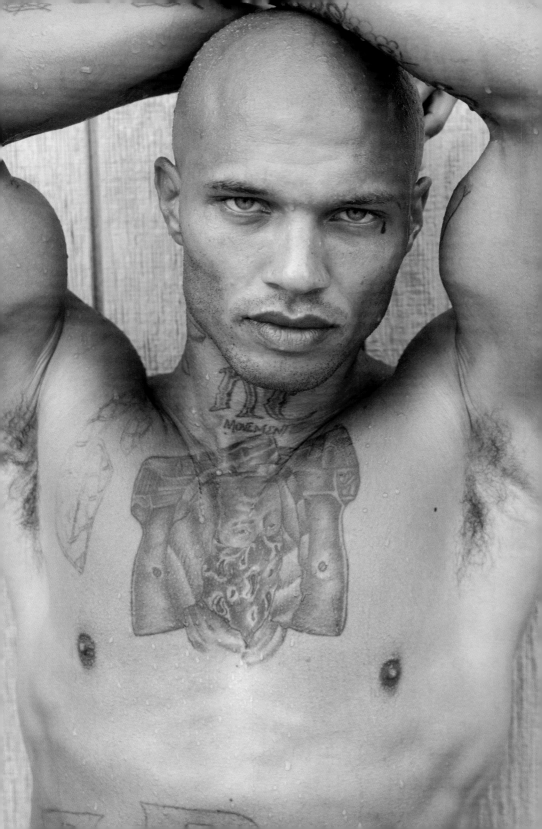

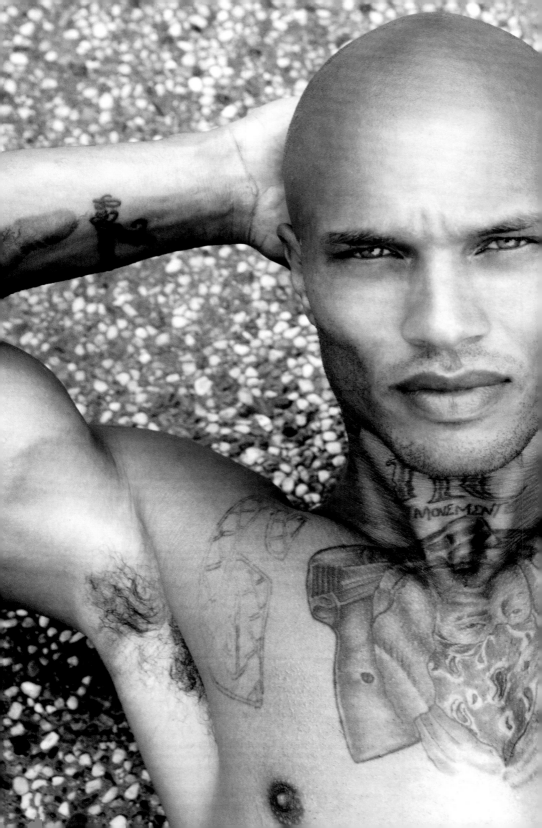

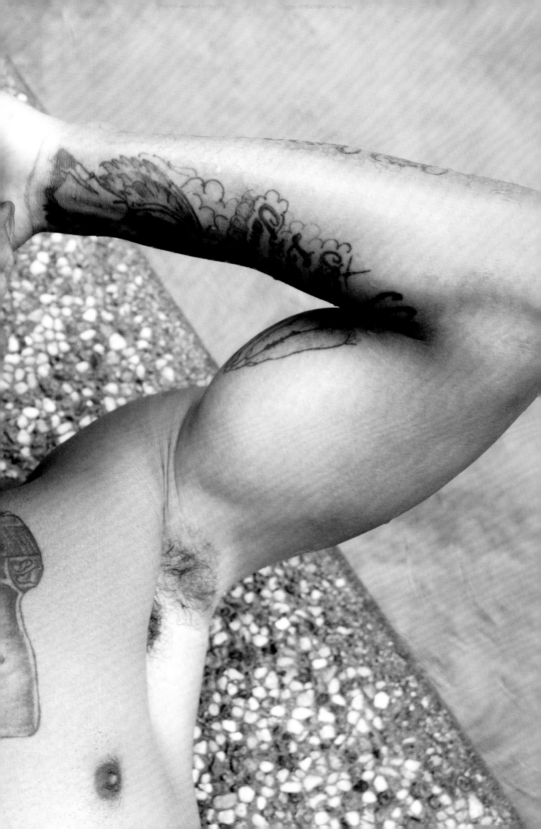

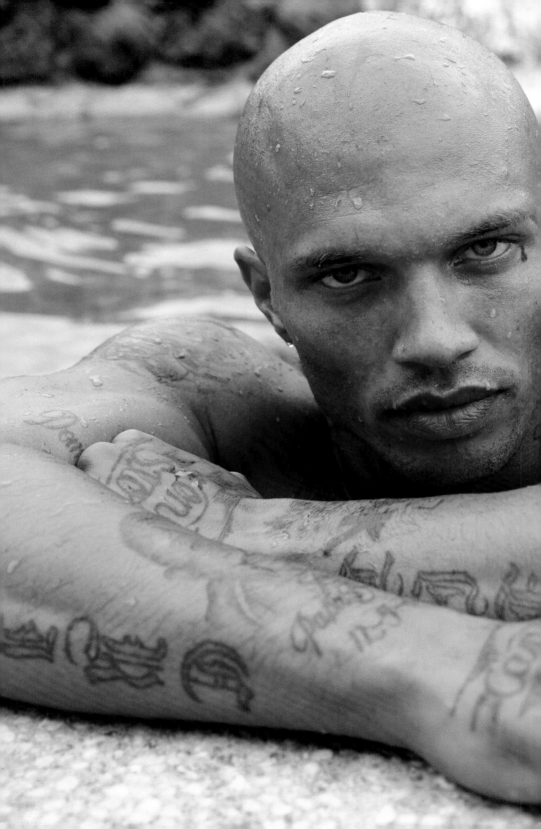

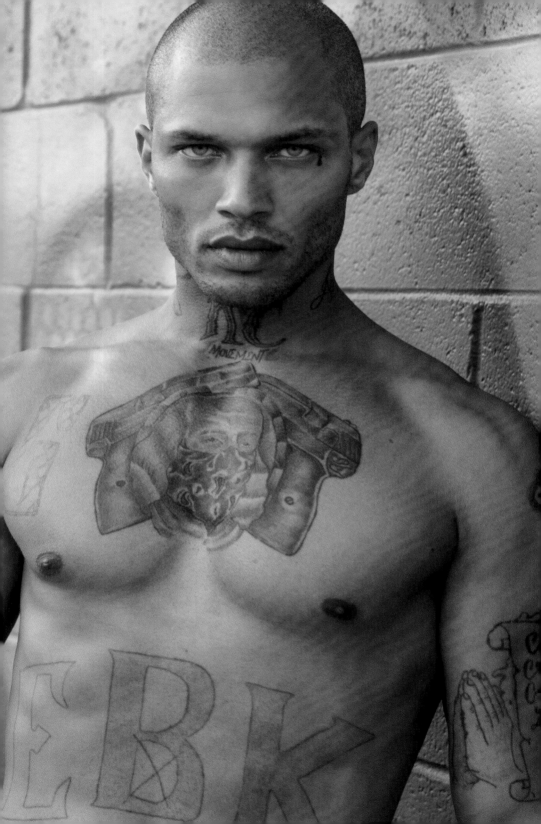

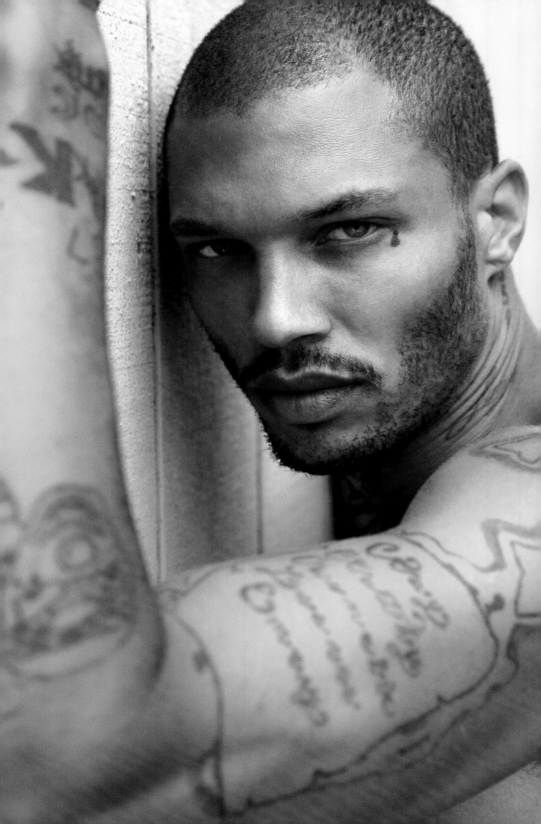

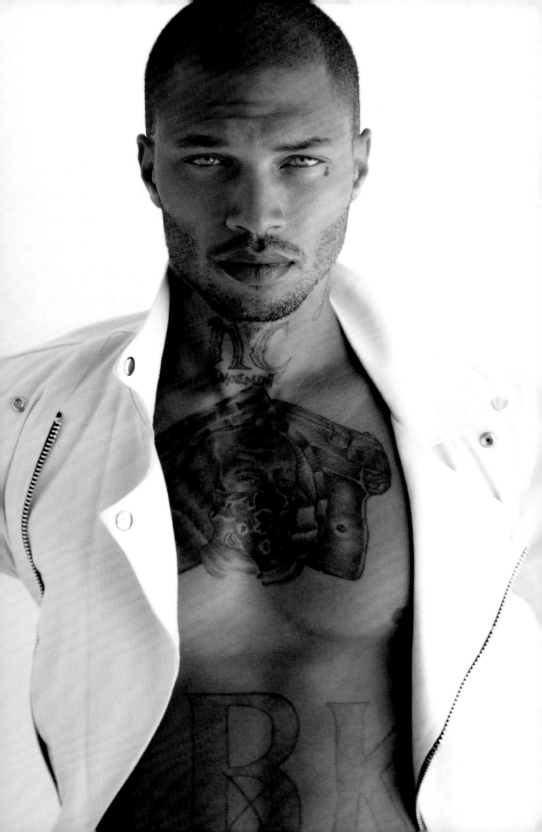

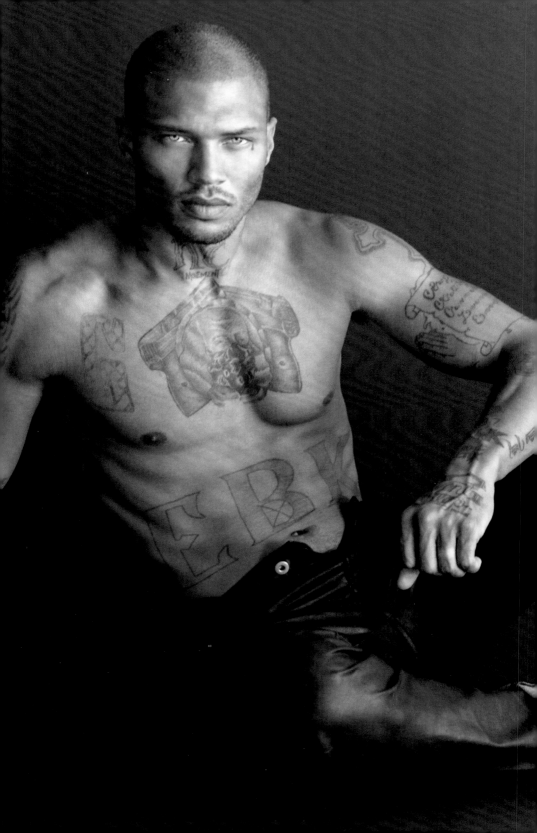

While I was on the road working, Melissa was home adapting to being in a relationship with someone who was more exposed than she was comfortable with. So much of our relationship was insular. It grew in those letters without any opinions weighing us down. It was just me, her, and the kids—our little family. She visited my family with me and took her time getting to know them, but on a day-to-day basis, she was more connected to me than anyone.

Being a model and a personality was an adventure that I was forced to embark on without her. There's no automatic here's-a-ticket-for-your-spouse-and-kids clause in a booking contract.

The first time Melissa joined me for an event out of the country, things went left. One of the early photoshoots I did was finally being released, and Melissa was coming with me to the reveal party to celebrate my accomplishment.

She joined Jim Jordan and me on an ill-fated trip to London. We were both really excited, and I was happy that she was coming with me on this adventure.

My agency had arranged a travel visa for me, and the flight went smoothly. My manager, Melissa, and I were in line to present our passports when something felt off. After a lifetime in the streets, you develop a sixth sense; it's the only way to survive. I see everything when I'm in public. I watch everyone the exact

same way I did when I was in prison.

The moment we stepped into the customs line, I had an eerie feeling that I wouldn't be waving to Big Ben anytime soon. I noticed three people standing in the back huddled together.

They were trying not to be obvious that they were looking at me, but I caught every glance. They were whispering to one another in a way that made it clear they knew who I was.

"Something's about to happen," I told Melissa and Jim.

Melissa had been in my life long enough to know that my instincts were on point. She knew that if I said something was about to happen, then something was about to happen. She started looking around Heathrow Airport for evidence of what I was telling her, bracing herself for whatever was next.

Jim dismissed me right away.

"You're tripping," he said.

He thought I was being paranoid and wrote off my warning.

"This is just your first time out of the country; people are different here," he tried to explain.

I knew better. I watched as the three of them eased over to us.

We walked up and handed the customs officer our passports. As soon the documents officially changed hands, the three people in the corner started marching over determinedly.

At this point they had stopped trying to pretend that their

presence wasn't planned. They walked straight up to me.

"Mr. Meeks, could you please come with us?"

They didn't ask me who I was because they already knew. They'd been waiting for me the entire time. Due to international law statutes, they just needed me to hand in my passport to try to gain entry into the country.

Even though I was technically standing in the country while waiting in the customs line, I still had not tried to officially gain entry into it. They separated me from Melissa and Jim right away.

"You guys can go in. You can do whatever," they told them.

Melissa, always protective, protested. "He's coming with us, though."

They remanded me into custody on the spot. They took me into one of the back rooms at Heathrow and interrogated me for the next seven and a half hours. The customs officers in the room knew more about my life than I did. They asked me about everything.

I tried to reason with them, even though I figured it probably wouldn't make a difference.

"You guys, my life is changed," I told them. "You have my work visa, so you know why I'm here. It's my very first magazine cover. It's the launch party, and Steven Klein shot it. He's the biggest fashion photographer in the world. They're throwing the

party for me in London."

They were unmoved.

I tried one last attempt. "You guys, Madonna's waiting for me. Madonna's gonna be there."

The material girl made it to the party, but when she got there, the guest of honor was missing in action.

The United Kingdom denied me access that day, and because I'd spent more than a year inside, banned me from entering the country for the next ten years.

They immediately extradited me.

They walked me through the airport, holding on to my arms and grasping at my clothes like I was going to run.

There were at least nine officers with machine guns and dogs. Prior to this I was just disappointed, but now I was pissed off.

"Guys, this is excessive. I'm in the terminal. Where am I gonna run to? You don't have to grab me like this. I didn't do anything."

They were just as stiff as the guards at Buckingham Palace.

"This is just protocol," they said.

I knew that was a lie. It was a publicity stunt. They wanted to send a message that the country was putting their foot down when it came to their immigration policy.

There was a growing conservative majority in the country,

and this was an easy way to show that the higher-ups in charge were committed to making their government appear as rigid as possible to the outside world.

I had applied for my visa, so they knew I was coming. They could have denied or withdrawn it at any time, yet they chose to approve it instead because they wanted to use my newfound fame to make a point. I decided to make a point of my own.

To add insult to injury, they didn't even fly me back to California, where we'd left from.

They flew me to New York and told me I had to figure it out from there. I knew what they were doing was wrong, so I pulled out my phone and started recording.

They told me to put my phone away, but it was important to me to document how they were trying to use me. I continued to record and forwarded the footage to Jim, who sent it to the media. I was upset that the trip didn't work out, but I felt good that people who were struggling all over the world were going to see that the same people telling them to pull themselves up by their bootstraps were the ones cutting them off at the knees.

I was upset that Melissa and I weren't able to have that experience. It was going to be the first big trip we'd had together since I was released. We had traveled to Hawaii multiple times and had gone to Puerto Rico for my birthday once. Levittown was

crazy. It was like the most beautiful chaos I had ever seen. However, the London trip was supposed to be special, and we were very disappointed not to experience it together.

No one really explains to you the toll it takes on a relationship when you're a public figure. On the one hand, it's so exciting to be able to go to all these places and to have all this money to finally buy the stuff you want, but on the other hand, if you don't have a very solid foundation within your relationship, things can blow up fast. When I was being pulled to different events and different cities, my mind was buried in work. I would go periods of time not being able to call my family.

It's very hard not to let your mind assume the worst when your husband is off traveling the world with models and celebrities. And she wasn't wrong. I had women coming at me from all different directions. It got to the point where I told my manager that if a female came over to flirt, then to make some kind of excuse to get me out of there. It didn't matter, though. Without being able to have Melissa there with me, it started to cause a lot of tension in our relationship.

It was something I wasn't used to. Melissa was always my ride or die. She was always there for me, and I never imagined my life without her. I cannot even imagine if the roles had been reversed how I would have reacted to her running around the world with a

bunch of underwear models. It's hard to be in that position. It caused a great deal of strain on our relationship, and we started fighting a lot. I would get frustrated with her and then she would get frustrated with me. It got to the point where I felt like we were always arguing about something.

It continued this way for a while. We would go back and forth between fighting and talking divorce to running back into each other's arms. We tried so hard to figure out a way to make it work and a way where we could both be happy. We even got to the point where we knew we needed counseling, but no matter how hard we both tried, it just never seemed like it was getting better. We continued in this unhealthy cycle where we were both very unhappy.

Eventually, we knew it was over. Melissa always had hoped that we would figure it out, but by then I had given up trying. It felt hopeless. We were still technically living together, but I was no longer staying at the house. We both started doing our own thing, and we let silence fill up the space between us.

CHAPTER 18: PLAYER HATER

Cannes, France, May 2017

It was when I was working in Cannes that I met Chloe Green.

Cannes is a city in the French Riviera, and it's one of the most beautiful places I've ever seen. It has these amazing beaches, all kinds of designer shops, a really fun nightlife scene, and phenomenal food.

I was brought there to walk in another Philipp Plein fashion show. It was his first resort show ever, and I was one of the models he chose to help him introduce that part of his work to a global stage.

It was a mind-blowing experience. The show was held in his private villa. He rolled out a pink carpet and filled his enormous stone fountains with bottles of premium champagne.

My fellow models included Paris Hilton, Sofia Richie, Winnie Harlow, and Daphne Groeneveld. Even Eva Longoria was sitting in the audience.

Afterward, Jim and I were invited to a party hosted by the CAA. The Creative Artists Agency is a huge full-service agency that has transformed ordinary people into superstars time and time again. When they call, you should probably come running.

Jim and I went together. He wanted people to get used to seeing my face around so that they could potentially consider me for further employment options. He wanted me there to meet everyone, and it was my goal to leave a lasting, positive impression.

I knew there were some people who didn't think I deserved the opportunities I was getting. They thought I was glamorizing crime by being able to go from an eight-by-six cell to magazine spreads. I wanted to prove them wrong and to show that with the proper support, anything was possible. I wanted to prove to them that I'm more than just a criminal who got lucky with a photo.

I'm grateful that I caught the attention of the public at a time when the idea of who could be considered a celebrity was changing. People like DaBaby, Cardi B, and K. Michelle were pushing back against the idea that you had to have a spotless past to survive. People were getting a chance to be rewarded for who they really were instead of being punished for it. True authenticity was gaining traction with the public. I still got a lot of hate, but I was also surprised by the amount of people who were supportive of me and wanted to see me succeed.

Leonardo DiCaprio and Tobey Maguire were at the party, and my manager introduced me to them. I couldn't believe my eyes.

These were some of the absolute best in the industry, and I was chatting with them like we were old friends. They welcomed me into their conversations with open arms. They never treated me like I was less than them or just some thug. They treated me like a person.

I was even blessed with an incredible opportunity to spend time with Tommy Hilfiger. It was such a pleasure getting to know him and his wife. They are some of the nicest people I have ever met. His journey is unbelievable, and I found him so inspiring.

I really enjoyed talking to all the different people at these functions. Everyone had a story to tell, and it was amazing to hear how they all ended up where they're at.

At that time, I wasn't even considering any kind of new romantic relationship at all. My focus was on my newfound career, and that was the center of my attention. Although I was surrounded by a lot of women, I wasn't trying to be some Casanova, running around Hollywood and seeing how many I could sleep with. I had enough going on, and I didn't even want to go there.

The CAA party was in the kind of huge chateau that you picture when someone tells you they're headed to the south of France. I stepped away to find the bathroom and got lost in the labyrinth of the mansion. That's when I stumbled into Chloe.

She had this accent that I found completely adorable. She was a little bit soft spoken, but she talked with ease and confidence. She knew exactly who she was, and she immediately sparked my interest.

We made small talk on the balcony. It wasn't like when I had met Melissa, where there was this instant, overwhelming connection. At that time, I was still pretty reserved because I wasn't in the mind frame to be allowing myself to catch feelings for someone. I just knew I enjoyed talking to her. She was smart, funny, and beautiful, and there was something about her energy that made me feel at ease. When Jim saw us conversing for longer than the normal small talk amount, he hopped into action to swoop me away.

"Hey, Leo, wants to talk to you," he said as he pulled me away from her.

We gave each other a quick smile before I disappeared into the crowd. I was there for a job, and I rapidly got my head back into the game.

Two nights later, Jim and I were guests at the amfAR gala. Philipp Plein had purchased two full tables to support the cause, which was for AIDS research. He invited us to attend with him and his group.

The annual gala is held at the Hotel du Cap-Eden-Roc in

Antibes. Proceeds from the lavish event help to underwrite some of their research efforts in the fight against HIV/AIDS.

It's one of the most coveted invitations in Cannes. Tickets for the gala begin in the $20,000 range, and tables can easily go for north of $200,000. There are similar galas in Palm Beach and Los Angeles, but the one in Cannes is where everyone wants to be.

The gala is a high-society melting pot and is attended by luminaries from every field. Tech tycoons, supermodels, Hollywood heavyweights, and old money magnates clamor for an invitation. We heard people whispering that one of the attendees who didn't make the initial guest list paid over $180,000 per plate. The first time I had even heard about the gala was when I got the invitation.

I had a great time, and I met a lot of people, including Nicki Minaj, who was nothing but gracious to me. We posed for a picture together, and later on I noticed there was a woman in the background. It turned out to be Chloe. I had no idea she was there, and we never interacted that night; we were just orbiting each other.

Jim and I met a really cool woman there named Gigi Hadid. She was incredibly laid back. We talked with her all evening. She told us that she had a membership to the Monte-Carlo Beach Club and that we were welcome to join her the next day if we

wanted to. It was a little over an hour away from where we were staying in Cannes.

It wasn't just my first time ever at a beach club in Monte-Carlo; it was my first time going to a beach club, period.

We had partied at the gala well into the night, but we still managed to arrive unfashionably early. Gigi wasn't there yet, but the staff let us in anyway. While we were waiting for her to arrive, my manager and I were strolling around the beach club. The water in Monte-Carlo was the clearest I had ever seen. I was enjoying the scenery when I heard someone call my name.

"Hey, Jeremy."

It was Chloe, sitting in the cabana with a couple of her friends. I called Jim over, and we joined them. We all talked and laughed together for the rest of the afternoon. Chloe was going in and out of the water. When she came back up from swimming, we would ask each other a few questions, then she would hop back into the water again. She seemed so happy and carefree. I admired it. We come from completely different worlds, and we found it fascinating to learn about the other person. We were so foreign to each other.

A few hours later, we got a message from Gigi, and she explained that we weren't at the right location. Not being familiar with Monaco, Chloe offered to take us there. When

we parted ways that day, I thought it would be the last time we would see each other.

The next day, Philipp Plein orchestrated a large dinner event at a Japanese restaurant called MayaBay. A big group of us were sitting around the table talking about the trip when I saw Chloe walk in. I couldn't believe it. It turned out that the restaurant was connected to the building where she lived. She sat with me, and we spent the rest of the evening just talking in our own little world. I was happier than I wanted to be. I wanted to ignore this thing I felt for her. I wanted to focus on my career. I wanted to ignore the fact that everything was pulling us toward each other, but I couldn't. I was so drawn to her quiet nature, her subtle confidence, and this cheerfulness that she radiated. I wanted to know her better.

When we first met, I had no idea who she was. I didn't follow the fashion industry, and I had no idea that she was the daughter of billionaire Philip Green. His nickname was King of the High Street. The business mogul owned Topshop, Miss Selfridge, and so many more. Twenty-five hundred outlets across the UK. He even owned Sears. There were no Topshops near San Quentin, and we sure weren't watching reruns of *Made in Chelsea* while I was locked up in prison.

She wasn't the type to scream that fact out either. She would

tell me things about her life but word it in such a subtle way that I really had no idea just how prominent she and her family were. We talked about our families, our likes and dislikes, and she was always so interested in learning all she could about me. By the end of that dinner at the Japanese restaurant, I was like a giddy teenager, and before the night ended, we had our first kiss.

I didn't really understand until people came up to me and said, "Oh, Chloe Green? She's . . ." and then they would rattle off her entire life history, making sure to attenuate the fact that she was a billionaire's daughter.

I even thought to myself, *Oh great. I can see the headlines now. Criminal dates the billionaire's daughter for her money.* Which I'm pretty sure ended up becoming an actual headline. I didn't care, though. I was tired of caring what people thought about me. People were very verbal about their negative views toward me, and I had to get to the point where I just shut off caring. You can't get into this business without some kind of protective shell, because if you let that stuff get to you, it will tear you down.

When I headed back to California, Chloe and I FaceTimed every single day for weeks. Sometimes we would talk for twelve hours straight. It very quickly went from being like giddy teens with a crush to full-blown infatuation.

I wasn't expecting to fall in love with Chloe. I didn't plan for it, and I also didn't know what to do. Melissa and I were in such a strange place. We weren't really speaking, but we were technically married, and I still had so much love for her, but I didn't know how to tell her that I had fallen in love with someone else. I didn't want to hurt her. I didn't want to tell her that the thing we had fought so much about, the thing she feared would happen, happened. I still kick myself in the ass for not sitting her down and respecting her enough to give her the truth. She deserved the truth, but instead, she found out when the media released a photo of Chloe and me together, half-naked in a clinch on a luxury yacht off the coast of Turkey.

I felt terrible. I didn't want her to find out like that. I've learned that the truth is always going to come out one way or another, and you might as well be the one to deliver it. I really felt bad on both ends. Both Melissa and Chloe received heat from the media because of that. I should have never let it get to that point. I should have been open with Melissa and filed the paperwork the moment I knew it was really over between us. I know I can never turn back time, but that is one I would have definitely done differently.

Luckily, Melissa's an incredible human being, and after a lot of work, conversations, and healing, we're in a very great place

now. I consider her one of my best friends, and we both continue to support each other through life.

Chloe and I ended up traveling everywhere. She showed me places I had never seen before. So much of our relationship was about exploring the world. We spent Christmas in the Maldives on a private island. For my birthday we went to Courchevel in the French Alps. Bear and I went scuba diving for the first time, and I fell in love with the ocean. We did two dives a day for thirty-two days straight. The three of us even swam with the sharks.

One of my favorite places we visited was Israel. It has this unexplainable energy, and Jerusalem is such a holy city. I was able to visit the Western Wall and put my prayers among the hundreds of others. Everyone writes their prayers on a piece of paper, and they place them within the cracks of the wall. As I put mine forward on the wall and prayed, my spirit felt so connected with the entire world around me. I was even lucky enough to be able to go under the wall where they found this hidden city underneath.

Chloe even went with me to spend time with my family in Washington. She was comfortable in the woods and in the mud. She was comfortable everywhere.

She didn't even take offense to my overbearing parole officer, who loved to stick her nose into our personal business.

My parole officer was a hater from day one. She was also more interested in Chloe than in making sure that I stayed on the straight and narrow. I love Los Angeles, but it's strange. Some people don't look twice at a celebrity. They see them so often that it becomes a regular occurrence. However, there are lots of others whose interest borders on obsession. It can get a little scary sometimes.

The first time I reported to my parole officer after transferring my paperwork to the Los Angeles office, Chloe went with me. She sat outside while I went through the process of proving I was ready to be out in the world. The officer knew everything about me, as she should have, but how much she knew about Chloe disturbed me.

"Chloe's out there, right?" she asked. "Go ahead. You call her in."

Chloe wasn't obligated to report for anything. It was clear to me that she just wanted to meet Chloe, to say that she had, and to poke into our relationship.

They made small talk before she started asking questions about our plans. At this point, I made no formal declarations that involved Chloe. In the eyes of the court, she had nothing to do with my parole and had as much standing as a stranger on the street.

"Are you planning to continue living with your manager for a while longer, or are you guys going to get your own place?" she asked, but she obviously already knew the answer.

Parolees are allowed to move. They can switch their address, but they have to inform their parole officers. I hadn't told them anything yet because there was nothing to tell. We had not signed a lease together, and there were no joint bank accounts. We were dating. That was perfectly legal.

"We looked at a couple of places in the past few days," I told her.

"Oh yeah?" she replied with a smirk. "Where?"

I told her that we were considering the Ten Thousand building, and she balked. The Ten Thousand building is the standard for luxury rentals in Los Angeles. Located at 10000 Santa Monica Boulevard, it's home to a ton of celebrities and influencers, and several magazine articles have been written about the benefits of staying at that stately address. She clucked about how expensive that would be and moved on to asking about my method of transportation. I told her I was driving a Porsche 911 because it was the truth, and there was nothing in my parole restrictions about the price of the cars I was allowed to drive.

"You're fresh out of federal prison, you know? You just got this new career. Don't you think you should be driving something like a Honda Accord and living in a place that's simpler?"

I can't say for certain, but I doubted that she gave advice in the other direction. I'm sure she wasn't out there talking to people who were sleeping on rolled-up cots and living in roach-infested halfway houses and telling them that they should be striving for bigger things.

"It's a car, it's registered, and I didn't steal it," I said with a grin.

Chloe and I ended up moving into a beautiful home in Calabasas. The parole officer was clearly miserable with her own life, and she showed it every time she came to do a home visit.

She paced through our sanctuary and inspected every item in the place with a sour expression on her face. There was a little knot on the bridge of her nose, and I couldn't help but stare at it as I watched her be openly resentful toward us in her puke-green pantsuits and wrinkled button ups. Her job was to help get my life on track, but she didn't appear to be very interested in me at all.

She zoomed in on Chloe every time she stopped by the house. Her resentment was so loud.

She talked only to Chloe during the home visits. I understood that she needed to make inquiries to whomever I was living with, but it didn't make sense that she directed all the questions toward her.

Chloe answered for me about what was going on in my life, what kind of jobs I had booked, what new things were happening in my career, and what was going on with my family. None of my

family members lived with us, or even near us, outside of my son, but she was obviously judging them based on their own interactions with law enforcement. There were times when she would walk in the house and not even really look at me; she would just make a beeline for Chloe like a bloodhound.

To her credit, Chloe took it in stride and answered her invasive questions and showed her all the attention she was looking for. There was no one to complain to. The judge was invested in my rehabilitation, but he wasn't at my beck and call. We just had to put up with the awkwardness, because if we refused to, we might end up talking through glass.

I completed my parole and took to the road without restrictions. I had traveled all around the world at this point, but there was always a clock on my excursions. I had to get in, do what I needed to, and get out so that I could report to my parole officer. Most parolees didn't have the long leash I did, and I was grateful, but being closer to freedom than ever before isn't being fully free.

Freedom was something that had been out of my grasp for my entire life. I went from childhood, to the system, into the streets, and back again. I always knew what was coming next.

It was an exciting time in my relationship with Chloe. We were

both adventurous people, but it was confined to the parameters of my commitment to the government. When I finally was released from parole, we spread our wings.

We were in our own little world, and I was living a life my younger self would have never believed.

Everything seemed perfect, but soon a darker world creeped in.

CHAPTER 19: HEALING

Los Angeles, California, 2016

Partying and doing drugs my whole life protected me from addiction for a long time in a weird way. I was never doing one thing long enough to develop a drug of choice. I definitely had an intensely addictive personality, but chaos was my preferred chemical stimulant.

I would overindulge for a night or two or go on a bender, but I was never a continuous user of any one thing. I never full zoned out and became truly addicted. I was experimenting.

When it was Y2K and we all thought the world was going to end, I took three red gel tabs of acid for the first time and watched *The Matrix*. It was an intense experience and one of my earliest attempts at self-soothing. I had already taken magic mushrooms before that, as they're popular in Washington State. That was kind of the beginning of my use of hallucinogenics and psychedelics. Mushrooms and hallucinogenics have helped me in a therapeutic way.

I have never not smoked weed. My entire life, from juvenile hall to county, jail to state prison, I smoked every day.

When I was on parole in the state of California, I was allowed

to smoke weed. But when I got out of federal prison, I was on federal parole, and so I couldn't smoke it because the federal government doesn't recognize the legality of cannabis in the same way that individual states do. So if I got caught smoking, it was a parole violation and I'd be back to prison—do not pass go, do not collect two hundred bucks.

I had to find a way to deal with my chronic pain. I had an enduring back issue from being beaten with baseball bats from the Brown Street Northerners as a teenager. The way they messed up my L1 has stayed with me my whole life.

Because I had a bulging disc and was unable to care for myself by smoking, I ended up getting a prescription for Norcos. This was one of the worst things that could have ever happened to me and my loved ones.

I never fully understood what people meant when they said once an addict, always an addict, because I hadn't touched a prescribed opiate yet. These came from my doctor, and yet they were more dangerous than anything I had ever taken. I was genetically predisposed to addiction, and they overwhelmed my system immediately.

When I got off parole, I was fully addicted. Instead of smoking weed recreationally, I was popping multiple Norcos to get through the day.

My doctor might as well have been a sales rep for the pharmaceutical company. He was writing me script after script after script after script after script after script. I had played around with drugs my whole life, but I had never been addicted to one. This feeling was new to me, and I didn't like it one bit. My eyes were bloodshot, and I was physically stressed out in other ways. I was constantly sweating whenever I would go too long without a pill.

Whenever I had a backache in Europe, doctors took a more holistic approach to health.

It was like one day I was telling a random dude in a white coat that my back hurt and that I didn't want to risk going back to jail by defying the courts and the next I'm crushing down pounds and pounds of Norcos, excusing myself and rushing to the bathroom so that I could get another one up my nose before I got the shakes.

It got to the point that I was buying hundreds of Norcos at a time. I switched from Norcos to Oxys after a while and then the next I knew, I was doing forty Oxycontin pills a day. I handed them out to my friends who were already using freely. Because I had access to an unlimited amount, it cost me nothing to be generous with my supply. I thought I was being helpful and sharing what I had with them.

The doctor never told me how addictive they were prior to writing me the first prescription. He didn't ask if I had a history of drug use or addiction. He didn't ask if I had a family history of addiction. According to the National Institute on Drug Abuse, "As much as half of a person's risk of becoming addicted to nicotine, alcohol, or other drugs depends on his or her genetic makeup."[2] This means I was doubly at risk for falling into addiction because each of my parents were addicted to heroin, an opioid in the same family as the pills I was taking.

I had a double dose of genetic predisposition, and my medical provider didn't bother to find that out before prescribing me lethal poison that they knew I would need to make it through the day.

No pharmacy or health-care provider cared. As long as my card went through, there were more pills.

Now it's all coming to light. The truth is coming out about these doctors and what they knew and didn't know about the "medicine" they were giving out to patients, aware that it could be a possible death sentence.

But it's happening after too many lives have been lost. Everyone deserves to know the truth about what they're putting inside their bodies, and they deserve the chance to heal

2 National Institute on Drug Abuse, "Genetics: The Blueprint of Health and Disease," August 5, 2019, https://nida.nih.gov/publications/drugfacts/genetics-epi-genetics-addiction.

themselves no matter how much money is sitting in their bank account.

Chloe and I were in the States when she started feeling off. It was then we suspected she might be pregnant.

There was a CVS down the street from our room at The Peninsula Beverly Hills. We figured it was a waste of gas to drive, so we walked hand in hand to pick up some pregnancy tests. A few hours later, it was official. I was going to be a daddy again.

I was really happy when I found out, and I was thrilled to be expanding my family with somebody I loved so much. My life was a whirlwind, and every day was something brand new that filled me with joy. This was just another thing to be grateful for.

Despite my enthusiasm, I was also a little bit afraid, because at the time, I still had never met her parents. I hadn't even been on a FaceTime call with them. I had no idea what they really thought about me, but I wanted them to know who I was beyond a negative news headline.

We flew to Monaco immediately so that I could meet her family before we broke the news that their clan was about to be bigger by one baby boy.

When we arrived, I had no idea what to expect. We didn't want her family to know that she was pregnant right away. We

wanted to feel it out, let them get to know me first, and then share our news with them.

When I got there, they invited me in with open arms. Not one person in her family made me feel out of place or like I didn't belong. They went out of their way to make me feel at home. Even her extended family members and friends made sincere efforts to connect with me. They invited me to their lunches, dinners, and special events. And they always asked if there was anything that I needed. They knew I hadn't been able to see a lot of my family during that time and that I didn't have any friends in Monaco, so they went out of their way to include me and welcome me into their community.

Not one person in her world ever made me feel judged. They could have taken one look at me and disregarded me like so many others. Instead, they chose to learn who I was in the present instead of judging me because of my past.

My family was a prime example of an intergenerational incarceration cycle. Both my mother and my father had problems with the law, so it was very likely that my brother, my sisters, and I would experience the same issues. These cycles can extend past four or five generations due to the issues associated with surviving one family member being removed from the home due to imprisonment.

The loss of income, the stigma, and the restrictions on where you can move to when you have a felony record all impacted our future prospects. We weren't the only family like this; we just happened to be the one that went viral.

When Chloe and I were all over the media, they were posting shots of all my family members and disclosing their various charges. They didn't care whose lives were affected by this. They just needed to run a story. So when I met Chloe's family, the image in the media was a pretty negative one. Not once did they treat me differently. Not once did they turn away.

We eventually told them that we were going to have a baby, and they were so excited to become grandparents. It was Chloe's first child, and they could not have been happier.

They opened their family and their home to both myself and Bear.

When I reached out to Melissa to ask if Bear could come to Monaco to live, she wasn't happy about it. She battled against the idea for quite some time. She didn't like the idea of not being the one to wake up with him every morning. After a lot of convincing arguments, she finally agreed. She's the kind of mother who is capable of putting her own feelings aside to see that this was a good opportunity for our ten-year-old son.

The Green family was gracious enough to enroll Bear in this

incredible school where he was able to thrive far beyond the way he did in public school. Private schools are different from public schools. Private schools teach kids how to be entrepreneurs, but public schools teach kids how to be employees. I wish every child had the same opportunities and education like the ones in that school did. I can't even imagine how different our world would be if we spent that kind of effort on all of our children.

Bear was very social, and he made a lot of friends. When we first got there, I was really afraid how he was going to react to the change, but he adjusted so nicely.

He even got his own driver to take him to school every day. He and Bear became really close, and they formed a very strong bond. They cared about each other so much.

On his days off, this man loved to ride motorcycles. He was an enthusiast and had a nice bike that he would ride to work every day. As a driver, he got to experience some pretty amazing vehicles, but in his eyes, nothing compared to his bike.

One day when he was picking me up from the airport, he told me that he popped a wheelie, and when he came down, he broke his bike. He was so bummed, and he didn't know when he would be able to get it fixed. When we got back to the house, I surprised him with the money to repair it. He was so good to us, and I wanted to be able to do something nice for him so that he could

fix his bike. He started crying and said he didn't want to accept the money, that he would just wait and save up. I told him that this was a gift because I appreciated how kind he was to my son. He finally accepted and immediately got his bike fixed.

A few weeks later, I got a call that he had crashed on his motorcycle and died on impact. I was devastated. I felt so much guilt. All I wanted to do was to thank him, but I couldn't help feeling responsible that he had died. Had I not given him that money, he may not have been on his bike that day. The whole family rushed back to Monaco to pay their respects and try to comfort his family.

I remember the scream Bear let out when he finally heard the news. His whole body just gave out, and he fell to the ground. He was broken and cried so hard that he couldn't breathe. Chloe's family didn't shy away from him or expect him to hold it together. They just comforted him and let him know it was okay to feel everything that he was experiencing.

Chloe's family was no stranger to negative judgments. They had their battles with being in the public eye too. They knew that articles like to run half-truths, or sometimes outright lies, and they never allowed that to be the only thing they saw of my family and me. They knew that people are more than just one thing and that they're more than their pasts and more than their

past mistakes.

When I was in Monaco, my whole world changed. I was hanging around a completely different crowd than I was used to. I was experiencing different kinds of conversations, and I really enjoyed being in a new environment. Even if I didn't necessarily look like I fit in, Chloe and her family always made me feel like I was one of them.

I remember the media posting a picture of Chloe and me playing Ping-Pong together like it was the most alien thing ever. When they were making comments and snapping photos, I wanted to say, "Hey, I was the Ping-Pong champ in juvenile hall." I bet they would have loved that. We were just two people building a relationship, and they treated us like a carnival freakshow.

CHAPTER 20: SURVIVOR'S REMORSE

For months and months, Chloe and I were on the go nonstop. After a while, I started having anxiety. In Monaco, it seemed like every night there was some kind of event. There's either a dinner, a gala, or a black-tie function. I started to feel overwhelmed and anxious. I didn't understand what was going on with me mentally, but I just knew that I wanted to run and hide away from the world.

At that time I wasn't able to explain exactly how I was feeling. Chloe would ask me to go do things, and it would cause arguments because I didn't know how to explain to her how I was feeling. I just shut down and shut everyone out. The more and more we fought, the more I pulled away from her, until I eventually made the decision to come back to the States.

I wasn't in the right mind space, and I felt like I needed time to be alone. It wasn't a situation where we got into an argument and abruptly ended things. It was kind of like this gradual transition, where I finally broke it down to her that I wasn't able to be what she needed. She deserved to be happy and to be with someone who made her happy, but at that time, I couldn't be that. I wasn't in the mental space to even be able to make myself happy.

It was a really hard time for me, and I knew I needed to find a way to get myself and my mind in a better place. I didn't know how to manage my emotions, and I needed to learn how. The only thing I knew how to do was to withdraw. I didn't know how to communicate with her.

After I got back to Los Angeles and was alone for a while, I decided I needed to stay alone. I told Chloe how I felt, and she was devastated. She just didn't understand how it could go from us being in Monaco, having my sons there, and things going so well to then me just shutting down and making that decision. But what I couldn't explain to her was that I could feel myself getting worse in my mind. I would feel all these emotions at the same time. I didn't know whether I wanted to run, jump, cry, laugh, punch someone, hug someone, jump off my balcony, or curl up into a ball on the floor and cry . . . all at once.

Sometimes I wanted to give up, but something told me that this was all part of God's plan, and I kept telling myself to keep going and that it would get better.

I never understood depression until this. I never understood how powerful it was and how painful it was. To know that I have all these amazing things going for me, to have people in my life who I love so much and who love me, to have these incredible children who I adore, but to then have this battle in my head be

so strong that I actually considered giving it all up. That's how much it clouds your mind and your judgment. It's like you're unable to see the world around you.

That's where I was, and no matter what Chloe said to me, she couldn't bring me out of that. I needed more help than she could give me. I needed a professional to help me start working through these things, and even then I wasn't sure if it would be successful.

When you're in that kind of headspace, it can make everything look dark, and she deserved the light. I couldn't expect her to continue waiting for me to be in a better place. I love her enough to want to see her happy, and all I wanted was for her to find someone who could do that for her. She didn't want it to end, but eventually she understood why I felt I had to leave.

Even through all that, she didn't throw hate at me or put blame on me. She has never tried to make me feel bad about anything. She is always so kind and caring.

I couldn't be luckier that my children have the mothers they do. Both Melissa and Chloe saved my life in ways they may never understand. They have been nothing but loving and supportive, even through my toughest times. The friendship and the bond that I have with them will be forever.

I started seeing this amazing counselor and put a lot of focus on self-healing. I knew something had to be done or I wasn't

going to make it through this.

It took a long time to pull myself out of that, and it's something that I'll probably always have to work on, but I'm so happy that I have people I can lean on for support. People who understand that when I get overwhelmed and withdraw, it's nothing personal. It's just what I have to do sometimes to give my mind the time it needs to calm and process my emotions.

A few years ago, I started doing therapies that included psilocybin mushrooms. It wasn't about getting high or anything; it was about doing self-work. I used mushrooms to access the deepest parts of myself that I had spent years burying. Once I tapped into some of those areas, I was able to start working through these difficult past traumas and experiences. That has probably helped me just as much as the suboxone.

During this time I found solace in spending time with my family. I got to visit more with my brother, Emery, and his family. His children, Emerson and Alya, are both beyond beautiful. They're the definition of mountain kids. They're growing up on fifteen acres of land in the mountains. They play with snakes and catch lizards. Alya is so athletic. I loved listening to Emerson's stories and watching them as they ran that house.

I'm so proud of my brother, for us not to grow up with a

father and to see him and his family. He's so dedicated. He works his ass off and then makes sure he's home in time to read books to his children before bed. He makes it to their events and soccer games. He's the most incredible father.

We both struggle with mental health issues, and when we get in that place, we know we'll always be there to bring each other back. I can't even begin to explain how supportive he's been in my times of need. All of my family. My mom stuck by my side and stayed in my ear, telling me I was doing good and to keep going.

One of my fondest memories with my mom was taking her skydiving. It was the first time for each of us. I remember the guys being surprised by how calm we both were. They didn't believe it was our first time. My mom didn't even hesitate; she just jumped right out of that plane. It was one of the most amazing things I have ever experienced. I think all kids go through a moment when they wish they could fly. Just grow some wings and fly away to another place. Skydiving is the closest thing to flying that you could ever get. There's something so freeing about looking at the world from that perspective and just letting your body go. I think it was the freest I had ever felt. You free fall for sixty seconds before they pull the shoot, and I remember just screaming at the top of my lungs. It was such a surreal experience.

When my mom came down, her landing couldn't have been smoother, and she looked at me with the biggest smile on her face. We had a cameraman record the entire thing, and I'm so grateful that we were able to capture such an amazing moment.

CHAPTER 21:
EMPOWERING YOUTH

Another thing I love doing is charity work. Chloe came with me the first time I visited a group home. She's always been involved in charities, and it's something that we used to talk a lot about. It was something we were both passionate about. We went to a group home like the one I had lived in as a kid, and I was able to talk to them and share my story.

On that first visit I met Rosalinda Vint, president of the nonprofit foundation Women of Substance and Men of Honor. She became like a mentor to me, and we worked together a lot. She had all the connections to the group homes and juvenile facilities, she knew the kids, and she had been working with the community for years. She helps set up days to bring numerous group homes together, and I can come in and spend time with the kids, hear their stories, and be someone they can just talk to—someone who can understand what they're going through.

So many kids in the system feel forgotten. They feel that they're not valued, and in return they don't value themselves. They don't see a light at the end of the tunnel, and I want to do everything I can to try to be a positive influence. I want to show them that even in a system that is set up for failure, they have the

capability to show the world what they're really made of and who they really are.

One time when I went out to talk to the kids, a couple of the boys couldn't join us. I was told they'd gotten into a fight and had to stay back. All the kids and I were hanging out, talking, eating lunch, and playing basketball, when I heard the story of why these two kids had gotten into a fight. At their group home, there weren't enough clothes, so all the kids were sharing clothes.

The boys got into a fight because when they heard I was coming, they both wanted to wear this one particular nice shirt. The next thing you know, they were having an all-out brawl over this shirt. I broke my heart when I heard that.

I remember not having clothes. I remember what it felt like to feel ashamed of the condition of your clothes, and I couldn't stand back and not help.

When you don't have money, everything costs money, and everything's expensive. However, when you have money and you're known, or you're a celebrity, an influencer, or a public figure, everything is free. People just give you stuff. You get free tickets to games, free clothes, all kinds of things. If you have a big enough following, any brand is going to give it to you for free. They want it promoted. They want the world to see that so-and-so is wearing their brand or using their products. But the people

who really need it, the people who can't afford to buy it, those kids who are sharing clothes, that's who these brands should be giving out free swag to. You can dress a celebrity and sell a lot of clothes, but you can also be a brand that changes a kid's life.

It got me to thinking. I know a lot of people. I know a lot of people at really big brands who would love to get involved and help those kids trapped in the system who didn't have anyone by giving them some clothes. I contacted my man Rich at Fashion Nova, because I'd been doing a lot of work with them and asked if they'd be willing to supply these kids with some clothes. He came back instantly, saying for sure, he'd love and would be honored to get involved and put together some packages; he said someone from his team would get in touch. They hit me the next day, asking how many kids and what their sizes were. We were talking more kids than I could count, but they stuffed boxes and boxes into a truck and sent them to the group homes. They put it together really quickly, and I was both impressed and humbled as well as incredibly grateful for the amount of clothes they donated to Rosalinda's foundation. It was a huge blessing when we brought the truck in, dropped off the boxes of clothes with Rosalinda, and distributed them to the kids. To see the looks on their faces as each kid got five outfits that they didn't have to share with anyone was genuinely touching. To see their raw

emotions put a lot of things into perspective for me. What Fashion Nova did was absolutely amazing.

When you don't have anything, the smallest things mean a lot, and they were shocked that someone cared enough to do that for them. To have this big brand like Fashion Nova hook them up, they just hugged me and cried. It was such a beautiful moment but also a sad one because no kid should ever have to be without.

There are so many kids out there who need people to care about them. They just need to be seen and supported. They need to have someone care enough to simply spend ten minutes on an email to try to help make their lives just a little bit better.

I believe that as celebrities, as adults, as parents, as humans, we can all do more. There are kids in these group homes and facilities who have never even committed a crime; they're there because they don't have someone to care for them and love them. They didn't have stability or a family. They never did anything wrong, and they never deserved to end up where they're at. They're thrown into these facilities and homes, and every year the funding gets smaller and smaller.

All these programs they once had are fading out, and these kids don't have the support or the opportunities they deserve. They're thrown into these facilities with nothing. How could we

not do more? These are our kids. They're our future. How can we expect our children to care about the future if we don't care enough to even make sure they're clothed?

I always think about what I can do to help the situation more, or to do more, and it's such a huge problem across the world that I wouldn't even know where to begin. All I can do is try to make a difference in my community and be an advocate for these kids. I want to be the type of advocate that I needed when I was their age.

When I hear these kids' stories, I'm blown away. Again, I've learned that absolutely everyone has a story. Everyone has been through shit. Everyone has been on a journey, and not one person has walked the same mile. The things these kids have gone through, no kid should ever have to experience. I'm in awe of their strength.

When I first started going there, I was hoping that I could help these kids, but I didn't realize how much I needed them. I didn't realize how healing it would be for me to be able to connect with them to share our stories. When I offer advice, they listen. I never try to scare them, but I'm very honest about how terrifying certain paths can be. They know I won't sugarcoat anything. I'll tell it exactly like it is, and I believe that they really respect that. They want to be talked to, not talked down to.

I remember speaking to this fourteen-year-old kid, who told me that he and a girl from another group home had gotten together, and they now had a nine-month-old baby. They both had been in the system their whole lives, living in group homes, and now they had this baby while they were still just kids themselves. He was asking me for advice on how to be a father and wondering how he was going to be able to take care of his child. He didn't know how to pay a bill. No one ever taught him how to write a check. He was just a kid, and he had no one there teaching him how to become a man and a father.

To be honest, these kids don't have much at all. They're kept in these houses with no programs and no help with any life skills; no one is teaching them how to be adults. They're supplied the bare minimum to keep them alive and then it's to get them in and get them out. They're shuffled through the system, and once they get out, they're not prepared to take on the world and be successful in it.

It's like they're set up for failure after they've already been failed their whole lives.

Sitting in our nice houses, it's so easy to get caught up in our own stuff and our own life that we forget that there are thousands and thousands of kids who are stuck in this system and who are

feeling completely hopeless. We must do more. They need more support, and that's why I go there and why I will continue to do everything I can for them because I was that same kid, and that is what I needed. That is what every one of these children needs.

I remember being in a group home when I was a kid and having people come in and talk to us. But it was never anyone who looked like me. It was always some rich White business owner who had never been through the things we had and who talked about how if we made good decisions, then we could run a business like him. I couldn't relate to him, and I always wished I had someone there who I could connect with. That's what I hope to be for these kids.

One of the things I tell the kids at the group homes is that birds of a feather flock together. If you want to be a drug dealer, surround yourself with drug dealers. If you want to be a successful businessman, surround yourself with businessmen. If you want to be an actor, surround yourself with actors. If you want to be a musician, surround yourself with musicians.

You have to do anything you can to submerge yourself inside the world that you want to live in. I really believe a big part of it is about energy—the energy you put out there and the energy you receive.

It's hard to find yourself in a positive energy when you've

experienced the things a lot of these kids have. They look around and wonder, *Now where the hell is the light?* It's hard to get out of that mindset when you've been in it for so long. I completely understand it. I lived it. It takes guidance and it takes work. And if the system isn't going to provide it, and if the people don't care enough to demand it, then they've got to find a way to do it for themselves.

It's all about valuing ourselves enough to want something better. Is their road going to be harder than most? Yeah, it is. It's a lot harder to make it to the top when you're starting at the bottom.

The one thing that I know for sure is that every single one of those kids is a fighter, and if anyone can do it, it's them. When they get to the top, they're going to know that they earned it and that they deserve it, and they're going to appreciate the hell out of it.

CHAPTER 22:
PANDEMIC PAUSE

Milan, Italy, February 2020

It was right before the pandemic when I finally figured out that whole YouTube thing. I was on a European trip, traveling to four different countries and documenting it with my videographer, Cisco. Cisco has this amazing eye for photography, and we had such an incredible time traveling together. We started out in Germany, then we headed to Milan so that I could walk in a few shows at Milan Fashion Week. I was proud to share the runway with Mac Dre's mother, Wanda Salvatto (a.k.a. Mac Wanda) at the Extremedy fashion show. We stood on top of cop cars and wore tongue-in-cheek nods to the street culture that inspired so much of what you see on runways today.

It was a great way to close out the season.

Cisco and I were supposed to head to Moscow next when we had gotten all turned around in the airport.

We were looking at one of the television screens at the gate where we were boarding, and they were warning people about a new virus. Apparently there had already been ten outbreaks in Milan.

The next morning, I was sicker than I had ever been in my

life. They shoved a wooden stick down the back of my throat, and when they took it out, it was coated in white mucus.

They communicated to me that they thought it was possibly strep throat but that it might be something else. I didn't know what was happening with my body, but I knew it wasn't good.

I wasn't the only one dealing with a mystery illness. Soon the whole world would be forced to slow down as well.

I feel like the pandemic hit me pretty hard. On the one hand, it was nice to have a forced break from all the traveling for work, but on the other hand, I wasn't able to visit Jayden. That was really hard for me. I have always liked my alone time and have had periods of isolation but never like this. It gave me a lot of time to think. I realized I was carrying an enormous amount of guilt inside me.

After my recovery, I still had friends who were addicted. I knew what they felt like. I knew how horrible it was to suffer through that addiction. Yet I was lucky enough to have had Chloe there to help me through it. They didn't have a Chloe. They didn't have access to the same kind of help that I did.

When I started on the Norcos, everyone in my circle was already doing it. The drugs were flooding the streets, and a lot of my old crowd was partaking. This wasn't the same shit we played around with as young kids.

This was engineered death, and when I would reconnect with my boys, I watched how it took them over.

Men who were so prideful about their bodies and what they could accomplish were emaciated down to skin and bones.

I drove all the way to Northern California after getting a call that one of my close friends was in the hospital. I rushed there only to be told that he'd just been released thirty minutes prior.

I rolled through the neighborhood looking for him, and when I found him, he was standing on a street corner already high. He looked terrible. The life had totally left his eyes.

He had that overwhelming smell of withdrawal. Opiates are so strong in your system that every sense gives you away when you try to quit. You begin to sweat them out, but as that juice seeps out of your pores, you'll smell that addict smell every single time. It broke my heart to see my best friend struggling with that poison. I wanted to help him, but you can't help someone who isn't ready to receive it.

And the services they offer here in the States are not like they are in Europe. Even with the help that I got, I still struggle every day, and it has left me with what I can only describe as survivor's remorse.

So I became preoccupied with their situations, and I became removed from what was going on in my everyday life. I felt

responsible because of how accessible my connection to the pill-popping doctor made the opiates. My surroundings changed when I got clean. But for the group of people that I unknowingly enabled, nothing had changed. They were still waking up in the same houses, with the same people, using the same drugs, and I needed to own up to the part I played in their addiction. We all have a choice, but I try to do everything I can to help them and to try to make it right.

West Hollywood, California, June 3, 2020

I watched the whole video. I knew I shouldn't have. I knew the eight minutes and forty-six seconds of horror were going to trigger me beyond belief, but I couldn't turn away.

George Floyd could have been one of my cousins, one of my friends, my brother, or me. I was furious but not surprised.

I was crying a lot. It brought up so many emotions for me. It felt like I was reliving that moment when I was inches away from my own death. I felt so many things, but all I wanted to do was either punch someone in the face or punch my screen.

The powerful are usually insulated from accountability by apathy. This was another example of how they were stuck in their ways. My place had a balcony that overlooked Los Angeles, and I stood out there watching hundreds and hundreds and hundreds of people marching.

I know I wasn't an innocent person, but the police aren't

supposed to brutalize or kill guilty people either. There were times when I wasn't convicted of anything, and I still came home bleeding. I knew that was wrong. No one would listen to me then, but they were listening now.

I couldn't just keep watching. I had to do something, so I left my house and took to the pavement to join the people who were speaking up on the streets in West Hollywood. I didn't speak at the march, but I had a platform, and I wanted to use it to talk about the injustice I was seeing. So I decided to do an interview with *Good Morning Britain*.

I knew I was no LeBron James, but while people were paying attention, I was going to say something worth hearing in these interviews.

What I saw at those protests was upsetting. The groups were very diverse, and often there were White people on the front line trying to speak out to protect Black and Brown bodies. When the police came through, they were punished for that. They were treated even worse than they were treating us. Their attitude appeared to me to be, "Oh, you're on their side? Let's give you a taste of what they get."

It's heartbreaking what people do to each other.

During the pandemic, there were a few people who were homeless and living on the streets outside my building.

Sometimes when I would go out on the balcony, I would throw them down some cash to help out.

I've lived on the streets. I remember being without, and you cannot imagine how amazing it feels to have someone show some kindness to you, so I like to help out in whatever ways I can. Either hook them up with some cash, or get them a sandwich, or toss them a jacket in the rain, that sort of thing.

One day when I was standing out on the balcony, I saw an older couple walk up and start verbally assaulting one of them for no reason other than that they were trying to make them feel like crap for being homeless on "their" street. You could just feel the shame radiating from this person as this rude, entitled couple laid in.

I marched right downstairs and gave them a piece of my mind. They were shocked that someone actually stood up to them, and they were embarrassed. Instead of just shutting up and going back to their place, they had to make a point to me first. They purposely started screaming, "Don't kill us!" and acting like they were afraid for their lives. They wanted everyone around us to think I was somehow threatening them when all I was trying to do was to tell them to leave this innocent person alone.

I know I shouldn't have let it get to me. They were rude people who didn't deserve the time of day, but for some reason it

really affected me. They took one look at my appearance and used it against me, to try to make everyone around us look at me like I was going to off them on the sidewalk. I know I can't change the way other people behave, or see me, or react to me, but it was just another sign to make sure that I never do that to someone else.

I will never judge a book by its cover. You can have the prettiest damn cover in the world but the content can be shit, and you can have the most torn-up, worn-out cover with content of gold. You just have to be willing to open the book and look inside.

In 2022, I lost my cousin to a fentanyl overdose. I was at my house when I got the call that she was in the hospital and on life support and that she wasn't going to make it. It hit me hard. I thought about all the times we hung out together growing up. I thought about her kids. I thought about how that drug stole her life way too young. She battled for years with addiction, and all it took was that one time. That one time that changed everything. That one time when there was no going back.

I thought about all those times when I had been on the verge of dying and how easily it could have been me. I never want my kids to feel that kind of pain, that kind of loss. I instantly went into this spiral of emotions that I didn't even know how to describe. Where everything hits you at once.

At that moment I got a phone call from my little sister Shelby, Mama Donna's daughter.

She said, "Jeremy, I think I just channeled you. I was writing, and I don't think what I wrote was for me. I think it was for you."

I said, "Is it about death?"

"Part of it," she replied before I explained to her what happened.

She read this poem to me. It was so powerful and hit me so hard. It was exactly what I was feeling then and what I had been feeling for a really long time.

That was how I know that energy is real. She had no idea what was going on with me and what had just happened with my cousin, but from hundreds of miles away, she still felt it, and it was exactly what I needed to hear.

This is the poem she wrote:

Everybody has something to say, but not today.

I am holding so much back; it is like a maze.

I dive in deep,

I don't wanna see all this pain that's inside of me

. . .

You think it is easy, because I got lucky?

I still have demons trying to play.

Money doesn't make them go away.

Through the cracks in my mind, they keep

seeping in.

But these thoughts are not mine . . . They're not

mine . . .

I don't wanna lose control,

Take this psilocybin, trying to work through all

the sin,

Figuring out what life I am in . . .

Cannot be everything to everyone, I am torn in

all directions.

First I gotta find me. My soul has gotta be freed.

These cuffs are off, but I still cannot breathe.

Struggling between feeling nothing,

and feeling everything . . .

I close my eyes, but I cannot sleep.

The things I will never say.

Now wait. Gotta wipe off this face,

wear a smile I cannot fake. Walk a line between

the snakes.

All the while losing the ones I love

in this game of give and take . . .

I am not afraid to die, but I am afraid to live . . .

Afraid to live in a world where these kids have to

live like I did.

So I pray . . . I pray every day.

I pray for the ones all trying to find their way.

And when it gets so dark, and you're thoughts

are heavy,

Just know you're not alone . . .

You're not alone . . .

CHAPTER 23:
LIGHTS, CAMERA, ACTION

It feels so good to be on a movie set. There are so many moving parts. Whenever I'm blessed with another opportunity to make a film, I always take a second to thank God, because each time feels surreal.

Sometimes I still can't believe that I've actually been in four movies with Vivica A. Fox. To be on set with the woman behind *Soul Food* and *Set It Off*, as well as with Darius McCrary from *Family Matters* and other legends, is extremely humbling. Sometimes we'll be in between takes, and I'll just stop and look at them and ask myself, *How is it possible that these are my coworkers and now my friends?*

Vivica has been such an important part of my journey. She always has this kind, fun nature, and she's always willing to help those around her learn. I felt like a sponge just trying to soak up as much information as possible. When she's in front of a camera, she steps into her characters with gracefulness. She's always so comfortable and confident. Her talents astonished me, and when I got to know her as a person, I felt so privileged. She is such a beautiful person inside and out, and I'm very grateful for

everything she has taught me.

I'm really fortunate to have met so many amazing people.

When I was introduced to Kara Sax with the Sax Agency, we instantly clicked. Signing on with Kara was life changing, for a lot of reasons. Right away she became more than just my manager, and her entire team became more than just my team.

Her husband became my boxing coach and a very good friend. Her kids are like my niece and nephew. They call me Uncle Jeremy, and they're just the sweetest kids. They're such an amazing family, and they welcomed me with open arms. I became friends with Kara's mother before she passed away.

They have become like family. They invite me to their family functions, to all the barbecues, all the birthdays and special events. I just feel so blessed to have them in my life. She works so hard, and she truly understands me. She has this way with words where she's able to perfectly articulate what I'm thinking.

Sometimes it's hard for me to get out what I'm trying to communicate, but she's able to interpret, and I'm left saying, "Yes! That's exactly what I'm trying to say!"

She's just amazing with words, and she advocates for me like no other. Every time I go onto a set or show up at a job, they always mention Kara and how good she is at her job. She takes her work very seriously, and she doesn't play. She crosses every t

and dots every i. She pushes for me 10,000 percent and always goes above and beyond to make sure that I'm protected in every single way possible and for every single deal that I do.

My first movie casting was a huge deal for me. Manny Halley and Jamal Hill thought enough of me to cast me as Saleem in the sequel to *True to the Game*. That was all I needed, a chance. It was something no one wanted to give me, my first opportunity to try acting in a film. I would go to auditions and meet with casting directors, but no one would allow me to prove what I had been working so hard on. They always wanted to wait and see what I had already done and who I had already worked with. No one wanted to just jump out there and be the first to put me on. But Manny and Jamal did.

It was my very first entry into the Teri Woods universe on-screen, but I was intimately familiar with what her art had to offer.

Teri Woods is an author who turned her vivid imagination into an empire. Her book *True to the Game* was rejected by multiple publishers before she decided to put it out on her own successfully. Her stories teach the reader about the peaks and valleys of life in the street.

I sat down with Manny and Jamal for a general meeting, and they mentioned that they had some upcoming projects they were

producing. When I heard the word *Dutch*, I flipped out. I was so excited!

I revealed to them that I had devoured her incredible books while I was doing time in state prison. I didn't have great reading comprehension skills, and these were the first stories I could actually lose myself in.

She spoke to me, and to people like me, in a language that we understood. She weaved lessons into the colorful imagery of her books. I saw myself in her words. From behind bars I traveled with Teri Woods's characters to the streets of Philadelphia and New York. I sat on Gah-Git's Philadelphia porch with Gena as she pined for her one true love, Quadir, in the summer heat, and I came up through the ranks of New Jersey's drug trade with Dutch as he tried to snuff out the prosecution's case against him without losing his plug. When I was turning the pages of those books, I could drown out the noise from everything that was going on in my prison tier and send myself somewhere else. If stashing shivs in my cell was a method of protecting my body from danger, reading was a way of protecting my mind.

When I finished the books, I yearned for more. I wanted another trilogy from the author who could take my mind away from where I was.

Teri Woods's books were given a label by society just like I

was. Her work was dubbed urban fiction and segregated in bookstores. She achieved her success without being a traditional author, just like I've managed to achieve success without being a traditional actor.

I signed a five-picture deal on the spot and excelled in the role. I was cast as Craze in the adaptation of another of her novels, *Dutch*. Teri Woods and I actually became friends. It felt unreal.

It was a fun challenge to play Craze because he was nothing like the person I was when I was involved in the criminal lifestyle. I wasn't a criminal mastermind. I was impulsive and wild and self-destructive. The character was methodical and logical. He was vicious and enjoyed carrying out complex and cruel punishments for people who crossed him. It triggered me slightly to get back into the streets on-screen. My life had been so removed from that since I started modeling and acting that it felt like going through a time warp, but by leaning into the differences between the character and who I was naturally as a person, I could really get into it.

When I was in prison and my boys were there cheering me on this journey, I felt so supported. They helped me get through some of the darkest times in my life. We were family. I have no idea what I would have done without them. After we all got out

and I started doing movies, I had this amazing idea.

I asked the producers to consider Terry and my boys for roles in the *True to the Game* trilogy. They had also read all the Teri Woods books, which were a godsend to all of us. They agreed and cast them all in the films with me. These were the same boys I'd hooked up at Pollution Solutions Incorporated, and it was Terry who was with me when I was arrested that last time. It felt so good to be able to go onto that set with them and earn some money making movies instead of hitting licks. They killed it too. I remember Terry's face when he was behind that camera. He was a natural, and he was having so much fun. It made my heart feel good. It's amazing what people can do when they're given a chance.

At one point, Terry and I went to Germany together. I was there to shoot a campaign for a new fragrance and then we went to this big red-carpet fundraiser event.

On our visit, I took him to several old churches, and we walked the streets exploring all these historical places. To sit back and watch him marvel at all the architecture and art in Europe was surreal.

There we were, two tatted-up ex-cons, walking around these fascinating cities, appreciating their history, and expanding our knowledge of art history and culture. It was like we were these

sponges soaking up all we could around us.

When we were on our way there, he didn't quite understand when I said there was a whole other world beyond what we knew, but when we arrived and he saw it for himself and felt it for himself, that's when he got it. It's an experience neither of us will ever forget.

The roles in the Teri Woods movies snowballed into other opportunities. I was cast in a BET+ streaming series called *Legacy* that premiered in March 2023. The show followed a mob boss who was dealing with sibling drama.

The job allowed me to show range and to work with even more legends like LisaRaye McCoy, Clifton Powell, AJ Johnson, and Ving Rhames. It was so humbling to be in their presence. I watched closely to try to learn everything that I could from them.

I'm the type of person who likes to study people when they don't know that I'm watching. It's the best way to not only calm yourself by remembering that everyone is human but also to see who they really are and what makes them special. To just sit back on set and literally look to my left and see LisaRaye and look to my right and see Ving Rhames was an amazing experience.

Ving and I were shooting a scene in a cemetery. The cameras were above us strapped to special tracks so that they could zoom in on our facial expressions. Right after the director called action,

Ving broke character to tell me something that had occurred to him.

"You should start thinking about doing a romantic comedy," he said with certainty.

Hearing him say that meant so much to me. I was spending hours practicing and meditating for that exact thing. I want to be in a romantic comedy.

In meetings I would tell potential partners that I was looking forward to bringing this new skill set I developed to the screen in different ways. I wanted to show that the guy with the scary tattoos can be the soft-spoken star with the klutzy demeanor in a rom-com, because I knew it was possible.

The director, Jamal Hill, was just sitting there kind of waiting for our conversation to end. I didn't dream of protesting for even a second. I was smart enough to know that when an OG is talking to you, you better shut the hell up and listen.

Ving dropped so many jewels on me about the industry and the importance of maintaining my work ethic. When the scene was finished, one of the other creatives on set came up to me and told me that they overheard our conversation and that they had a script for a romantic comedy they thought I might be right for. Because Ving was open to me and wanted to uplift me, I had another opportunity sent my way.

After we wrapped filming, he took the time to check in on me and see how I was doing just a couple of days after Thanksgiving. Artists are very empathic people, and I think he sensed that I would appreciate his encouragement. He asked about my upcoming projects and made sure that I was still taking acting classes. I was so thankful that somebody like him would take the time to pour into me.

Every once in a while I still hit those moments when I was weighed down with my negative self-talk, and I think to myself, *Why am I deserving of the chance to get out, stay out, and make a life for myself?*

However, I try my best in those moments to remember that although I didn't ask for or predict this, it happened, and the best thing I can do to demonstrate the tremendous gratitude I feel is to live up to the occasion. I'm going to prove to myself that I am deserving of this blessing.

Another way I try to honor what I've been given is to shine a light on those who are not as fortunate.

I know that I'm not the only person who has ever walked out of a jail cell with something to offer society. I'm not the only felon to develop a skill and apply it to a life-changing career.

I'm blessed to be in this position because there are so many young brothers and sisters who are creatives and artists, but their

surroundings and their lack of opportunities don't allow them to be who they are. Or they might not even have the chance to be able to figure out who they are and what they want. I didn't know I was a creative until I had the opportunity to engage with the arts in a completely different way. It felt right for me when I went from consumer to creator. I had zero idea that there was another way to channel the experiences I feel, to channel my emotions, but now that I'm in the privileged position to be able to do what I want with my life, without fear, I chose to be able to express myself creatively for a living. It's self-soothing, and I hope that it can contribute to others' healing one day.

I'm serious about doing this the right way.

I don't want to just show up and stamp my face on what someone else is doing. I want to do the work and to be recognized for my own contributions.

When you're afforded these opportunities, you want to make the most of them. I did that, and now I know I have to keep going.

I remember when I first started doing a bunch of interviews, and I used to hear the same thing over and over again: "Here we have the hot mug shot guy." I understand that people are curious about my background, and it would be ridiculous for me to ask people to not refer to me as this or that, but I knew I wanted to be so much more

than just that one day.

I wanted to be known as more than just the Prison Bae, the Hot Felon, or the Blue-Eyed Bandit. I still embrace it because it's a part of my journey and will always be a part of my blessing, but I hoped that showing the world that I was capable of putting in the work and striving for more that I might get them see that I'm more than the "hot mug shot guy."

I'm dreaming bigger than I ever have right now. I can see myself directing or starting my own production company and running it with the people closest to me. When I think about what is possible for my life and for the lives that I'm fortunate enough to touch, I no longer see limits. I'm able to think about more than just the next few hours.

I'm putting in the work to make those dreams a reality. I study at the MAD Acting Studio under Max Decker. There's a Jack in the Box on the corner. It's a subtle reminder that real accomplishments aren't gold fronts that can be crushed by tires and that there's so much more worth valuing. Mastery over self trumps the high you feel from hitting a lick, doing a line, or copping some crazy accessories.

There are days when I walk into acting class at 7:00 p.m. and walk out at midnight, and I still leave feeling like I want to do a little more to earn my spot. I sit in classes, and I watch the caliber

of my classmates' talent. I understand that there are people who have been spending their whole lives chasing the opportunities that I got because of a viral photo, and I want to do my best to succeed so that I can position myself to make opportunities for others.

Forcing things is not the answer. I know that now. Instead of blustering through, I prepare myself and let the universe do its thing.

I'm already hearing less and less of "Aren't you the mug shot guy?" and more and more of "I just watched you in that movie!" It feels great to know that the work is paying off. It proves to me that I can be whatever I want to be.

When I think about the amount of people who are behind a wall and who have these amazing talents that will never be shown outside of a barbed wire courtyard, it makes me very sad.

Some of the most brilliant minds I have seen are behind those thick prison walls. These people were born with such amazing gifts, but they didn't have an outlet, they didn't have any opportunities, and this led them to making decisions and living lives that ended with them being put in prison. It was very sad to see all that talent go to waste, sitting in a box away from the world. If people would just take one second to open up that box and look inside, they'd be awed by what they saw.

I've heard brothers sing hymns in prison that touched my soul. I know for a fact that the best rapper alive is locked up. Some of the most talented, special, and unique people I have ever met in my life are all rotting behind those walls.

There were times when I was getting out of prison and I didn't want to leave my homies, because I knew that there was a high likelihood that I might never see them again.

I was blessed to be given a chance, but people with blue eyes and high cheekbones aren't the only ones who deserve an opportunity and a shot at redemption.

When I was surrounded in that underground life of dealing and stealing, I met some of the hardest-working people in the world. They're hustling twenty-four hours a day. They're solving problems, they're running, they're planning, and they're constantly making moves.

They're the entrepreneurs of the underground world. I can't even imagine what they'd be capable of if, at a young age, those talents and that drive had been nurtured. I picture what their lives would be like had they received the kind of support and the opportunities they needed. If they had been guided in a direction where they could use those skills to start legal businesses.

There are thousands and thousands of people in that underground world because they feel that they don't have any

other choice and because that's the only thing they know. It's the only thing they were taught. If there was some way that we could start supporting these kids when they're young in the way that they need, they'd see that they have other options. That support starts in the home and in the school systems.

Our public education system is not designed to help children thrive. It especially is not structured to help children who come from troubled backgrounds. It's going to be more difficult for those kids starting at the bottom to make it to the top. They have to work harder, and our focus needs to be on how we can support them.

We must spend more time and money on organizing better school systems that cater to the specific needs of the child. It must be more individualized and more inclusive. What blows my mind is that we as a society are smart enough to send robots to Mars and shoot humans into space, but we still haven't figured out how to create better environments for our children.

We spend millions and millions of dollars on the juvenile and prison systems playing cleanup crew to "rehabilitate" people after they've committed a crime. Those millions and millions of dollars need to be spent on the preventive side. Those millions of dollars should be put into the school systems and into the community to support the people where they are.

Most of the issues we're facing stem from poverty, addiction, abuse, lack of mental health support, chaos, and trauma. To find a solution, we need to focus on these core aspects of the problem instead of putting a Band-Aid over it. We need to be asking, "How can we create supportive and safe living and learning environments for our youth?"

The majority of the public school systems that I have seen operate with the goal of getting them in, getting them out, and keeping their numbers good.

All kids deserve better than that, not just the ones whose parents can afford it.

CHAPTER 24:
LEGACY

Los Angeles, California, March 2, 2023

I will say that once I had gotten behind the scenes, my perceptions about the movie industry really changed. Some people think that actors and artists have it easy. They see their life on the screen and think, *I want that, or I can do that,* but they don't have a clear picture of what really goes on. There is so much work that goes into a project. It's insane.

It's not, "I have an idea for a movie—let's do this." It's months and months, and sometimes years and years, of orchestrating and planning every single aspect and every single step of the project before they can step onto a set.

I have an entirely new appreciation for the people and the crews that make these projects happen. They are some of the hardest-working people I have ever met in my life. They show up ready to go. They're the first to arrive and the last to leave.

In between takes I like to talk to people and get to know them. Some people seem surprised by that fact. When I start talking to them, they get this look on their face like they're thinking, *Wow, you're actually taking the time to talk to me? You want to know about me?*

It's kind of sad because some—not all, thank goodness, but some—act as if they're better than others. They look at the crew and don't give them the time of day because they think that talking to a crew member isn't going to enhance their career. They're so focused on and strategic with their moves that if they don't see an interaction benefiting them in some way, then they simply don't engage.

I don't ever want to be that person. I want to know people. I'm interested in hearing their stories, and for me, my conversations with them are just as beneficial as the ones I have with executives. Sometimes even more so. This life is so short in the grand scheme of things. This is the only time that I have on this planet, and I want it to mean more—more than thinking, *What can I get out of this, and how much money can I make?* Obviously, we all need money to survive, but what I think about is what I'll be able to take with me when my time is over in this life. It's not the money.

Money will always come and go, but those connections you make with others, those moments when you're able to learn from another person or teach another person—those are what I believe will live on.

We live in a world that can make people feel so small, so inadequate, and so powerless. It's up to us to do our part to

spread love and kindness and to do everything we can to make sure we aren't contributing to another person's pain.

I had to learn that lesson the hard way. I had to do the work, and I also had to figure out how to forgive myself for the pain that I have caused in other people's lives. I had to change my perspective. I had to see the value in myself and see the value in other people. Now part of my journey and a way to atone for some of the things I've done is to do everything in my power to make sure that other people see their value and to make sure that I'm always valuing myself.

I want to help others who once saw the world like I did—as hopeless.

CHAPTER 25:
SELF-DISCOVERY

Fort Wayne, Indiana, 2022

One of the most incredible and healing experiences I've had was when I made the decision to hit a theater stage. It was my first play, *Her Lies, His Secrets*, written by DP Demarco. I had never stepped foot into a theater of any kind until I was on the stage in a leading role. I had never seen a theatrical play in my life besides the little ones put on in the cafeteria in grade school for the parents.

Theater came into my life in a very interesting way. While I was at the gym, I was talking to this woman. She was asking about the projects I was working on and why I had never done a play before—a stage play. She thought it would be incredible to be up there live and that the energy would be amazing.

When I was a kid, I had a hard time speaking in front of people. It was a fear of mine. It's different with films. You work with your crew, and you can retake mistakes. However, with stage plays, you don't have that kind of buffer, and the thought of it made me nervous. I don't want the fear of something to hold me back from trying new things. I want to be challenged and explore different avenues. I want to see everything that I'm capable of.

The more she and I talked about it, the more I wanted to do

it. By the end of the conversation, I was convinced that I could do it and that I wanted to try.

An hour later, while I was still at the gym, I got a call from my manager, Kara, and she asked if I would be interested in doing a theatrical play. She had just received word that a role had come in, and she immediately got ahold of me. It's so crazy how God works and how fast that opportunity came into my life.

I had thirty-three pages of dialogue, a fear of public speaking, and a goal to get past it. I spent hours practicing the lines. For two months straight, Shelby and I ran these lines back and forth over the phone. I wanted to make sure I was ready.

By the time I got there, I was off book already. I had all my lines memorized, and I felt confident. All that was left to do now was to get a feel for the stage and to dive into rehearsals. It was so different because, during stage plays, you're learning how to interact with a live audience as well as with your fellow actors and environment. With plays, everything is so much more theatrical and big. You need to have bigger movements and voices to make sure the entire audience can feel it.

I was a lot more nervous prior to getting there than I was when I arrived. I just felt really excited to be there. I remember being at the back of the stage where I could hear the audience

coming in. I believe there were about twenty-seven hundred seats, and it was sold out. The entire theater was packed. When I heard all the voices, the adrenaline built inside me. When they pulled the curtain back and I stepped onto that stage for the first time, it was a feeling I had never experienced before.

I've been hooked since the first time I walked onto that stage. I had caught the bug.

I remember being onstage between scenes and thinking to myself, *Man, if my homies could see me right now, they'd be blown away.* They've always known me to conduct myself in a certain way. I had my guard up, and I had my game face on. I've always cracked jokes, but just picturing them seeing me up on that stage being all theatrical, it just made me laugh.

I knew when I was up there that this was where I wanted to be, and it made me happy to be there. It feels so good to know that I have a purpose and that I can achieve it. I never had an outlet as a child to be theatrical or artistic or creative.

The script was beautifully written, and the entire team was absolutely amazing.

With thirty-three pages of dialogue, there were no cushions or do-overs.

"Remain vulnerable," I remember my coach advising me.

He had no idea that I had already been working on that for

years. I followed all the steps. I worked to really create a backstory, not only for this role but also for each character in every project I was in. I did this so that I could have the proper context to portray the nuances of their personalities. All these different layers that you have to create in order to really characterize a person resonated with me. It was a reminder that nobody was just one experience, one perspective, one feeling.

Every experience that I had throughout my life—falling in love, fighting in the streets, building a family, repairing friendships—they all came in handy.

It paid off when I got to this point in my life. They were tools I could draw from.

It was the real deal, and it was electrifying.

Modeling is cool, but it doesn't give me that same level of fulfillment that came with a serious challenge like stage acting.

After so many years of suppressing my emotions, it felt good to have them at my fingertips and to wield them the way I wanted. It was a new sensation to use them to build something for myself instead of tearing it down.

That night, after the play, I think I slept better than I have in my entire life. I had so much adrenaline running through me that it was the best natural high I had ever felt. At the end of the night when my body had settled down, it was lights out.

CHAPTER 26: SOUL TRIBES

My path has opened a lot of different doors for me. It has also led me to meet some incredible people. It's so different when you hear about people in the media and then you actually meet them in person. The media can only portray a small part about a person, and much of the time they don't actually capture their true nature.

I've come to realize that each person is unique, and I've been able to learn something from all of them. I don't like superficial conversations. There's something in my brain that causes me to tune out when I try to make small talk. I have a hard time discussing the weather or the new gossip around town. I tend to gravitate toward people who bring out the deeper sides of me.

I want to build relationships that matter. I don't ever want my life to be solely transactional.

In this business, much of it is what can I do for you and what can you do for me. And that's okay. It's the world we live in and what makes it go around, but I want to build meaningful relationships where, yes, we can both benefit from it while also ensuring that we care about and learn from each other. Relationships where we build each other up and cheer each other

on. Where someone else's success isn't seen as a threat to their own success.

I feel like I've been really lucky in that way. The majority of my projects have been filled with people who aren't superficial conversation types. They're creatives. They're free spirits. They're hard workers.

There's a guy I met on the set of *Dutch*, Miles, who became my soul brother. From the moment we met, we just clicked. When I'm hanging out with Miles, he opens up this creative side in me, and we can spend hours talking about movie ideas, TV shows, and music. He's one of those all-over-the-board talented people, and he just blew me away when I heard his music.

It had been a really long time since I had done any music. I had been so focused on modeling and learning all I could about the acting side of things that I kind of forgot how much I enjoyed creating music. I ended up meeting Tommy Brown and Mr. Franks who are both extremely talented writers and music producers. They helped create songs like Ariana Grande's "POV" and "Positions" as well as Justin Bieber's song "Holy." The list of incredible music they have created is endless.

I was invited to Tommy's place, and it was the first time I had been inside a real studio. The setup was like a dream. He had all the best equipment, with these cool lights decorating the walls. It

had a whole vibe. I saw the line of plaques and awards across the wall and was made speechless by all their accomplishments.

They were all the most laid-back people who just loved music. They can hop on their equipment and minutes later have these amazing sounds radiating through the air. I sat there in awe of how their minds work and how they're able to put that together with ease.

It seemed like music came so naturally to them. But when I looked deeper, I realized that although they have natural-born talent and an ear for it, it took years and years of practice, and years of honing that ear, to get where they are.

I was absolutely inspired by them. I was kind of intimidated at first to try to rap or anything because I was surrounded by a roomful of off-the-charts talent, but it didn't take long for them to break my shell. It was amazing to play around with the music, freestyle, and watch them work their magic. I fell in love with music all over again.

I pictured myself as a kid in that makeshift closet studio with our little eight track recorder and just smiled. If my teenage self had any idea where I would be sitting years later . . . I can definitely see myself doing some music in the future.

I see myself doing a lot of different things. It could be the ADHD, but I'm all over the board when it comes to interests. I

don't think I'll ever want to settle into just one career field. I want to experience it all.

Another person who has changed my life is Ugo Mozie. Ugo and I were introduced through Jim Jordan back in 2016. Jim had brought Ugo in to style me for a few photoshoots. He also wanted to introduce me to one of the most world-renowned stylists in the game. Ugo put out his first fashion line at eighteen years old. He has styled entertainment powerhouses like Beyoncé and Celine Dion. He's such an amazing artist, and I was so honored to be able to work with him.

Jim wanted me to start making connections in the industry, but at the time I had no idea how deep of a connection I would make with Ugo. I had no idea when I walked onto that shoot that I was about to meet a person who would change my life. We bonded instantly, and a while later we ran into each other when we were staying at the same hotel in Paris for fashion week. We stayed at the same hotel again when we were both in Milan and went out exploring the city. Then I saw him again in Dubai.

It was almost as if the universe knew this man was going to change my life and orchestrated the whole damn thing. We started hanging out a lot more, and I even started going to this monthly campout where a group of about ten people get together and camp on the ocean.

It's called Camp Gratitude. We sit around the fire, write down our intentions on a piece of paper, and then burn them. Afterward, we open ourselves up and have these abyss-deep conversations.

This group of people allows themselves to be vulnerable and honest with one another. It's such a safe space for everyone. No one feels judged or is afraid to speak exactly what's in their hearts. Add it to the list of all the people and the moments that continue to save my life and keep me going.

I'm so grateful that God put Ugo in my life and for the connections I've been able to make because of that. I was able to meet and build friendships with his sister and the twins, Coco and Breezy, who are wonderful free-spirited souls and creatives. They all brought me into their community, and it's just been a blessing.

Life has so much pressure in it. Pressure to do that, get this done, go here, pay that, fix this. We're all running from place to place in such a hurry that our lives are passing us by.

Before you know it, we're going to be at the end of the road, thinking to ourselves, *Where the hell did all the time go?*

When everything is going so fast, it's hard to allow yourself to appreciate the moment. To just slow down and feel the happiness in that moment. When life starts speeding up, being out in nature

and having these campouts are such a healing way to slow it down.

It's my time to check back in with my heart and my mind.

CHAPTER 27:
AFTER HAPPILY EVER AFTER

Los Angeles, California, 2022

I looked directly into the camera and apologized for the way that things happened. I made sure that I said it at least ten, fifteen times—loudly. I said it to the camera operators. I said it to the producers. I said it to every castmate.

I said it to her. I made sure that I said it to her numerous times, one right after the other, in the hope that the producers would show it on air. I wanted the world to know how sorry I was for the way things happened with Melissa. I gave them the eye to convey, *Please, I want the world to see this*, but they did not.

Melissa and I had signed on to do a BET reality show called *After Happily Ever After* together. The premise of the show, hosted by the rapper Bow Wow, was to bring several former celebrity couples together so that one of the ex-partners could play matchmaker for the other.

I thought that it might be the perfect forum for a public apology and for everyone to see how Melissa and I truly were as people. I had hoped that it would give me an opportunity to

apologize on a grand scale because she was embarrassed on a grand scale.

I was against going on the show at first. I wasn't sure that it was a good idea, but Melissa wanted to try it out, and I wasn't going to deny her any opportunity that would help her career and what she was trying to accomplish. It was important for me to be supportive of her the way she had always been supportive of me.

I knew that they were going to edit it and that I had no control over how they would choose to do that. I understand how the industry works and that they need to provide content that keeps you sucked in. That's how they make their money, and a sappy apology doesn't always make that cut. But it didn't stop me from trying. I kept making eye contact with the cameraman, and he would just smile, knowing exactly what I was doing.

Prior to signing on to the show, Melissa and I had numerous conversations, and I was very honest with her about everything that I was feeling when we parted ways. I expressed to her how terribly sorry I was, and still am, for being unable to give her the love she was worthy of. By communicating and acknowledging each other's perspective, we got into a great rhythm as friends and co-parents.

She has changed the way I see relationships, romantic and otherwise. I don't ever want to hurt anyone the way I hurt her. We

still go bowling on a regular basis (thankfully, our trips are less eventful these days). I'm grateful that she was willing to hear me out and that she allows me not only to parent our children but also to be a part of her life.

One of the most important lessons I've learned is to always be very clear and honest about how I'm feeling. Most of the issues I've had in my relationships happened because I shut down and shut off. I want to avoid things that don't feel good, and that has caused a lot more pain in the long run.

Today I try my best to be an open book with no room for interpretation, and I've found that most people really appreciate that. I value authenticity and honesty in the people I surround myself with, so I offer those qualities back to them.

CHAPTER 28:
FATHER TRIES BEST

Sometimes life doesn't feel real until I'm looking at my sons. I'm able to see myself in both of my children, but I see each of their mothers in them as well, and I'm truly grateful for that.

Something that is very special to me is waking up my kids in the morning with a kiss. They give me these big hugs, and we say our little prayers and repeat words of affirmation.

My oldest son is the coolest person I have ever met in my life. I love seeing the world through his eyes. He's my first, my rock, my life, and my soul. He's lived in the hood. He's seen people die. He lived in Monte-Carlo and went to the International School of Monaco. He knows how to speak French. He's traveled all over the world and can converse fluently on foreign affairs. He's seen so much, and he's only fourteen. I love exploring with him. There's nothing like it when we're together. He knows that he's free to ask me anything and that I'll always give it to him straight.

He's ahead of his time. He's an athlete just like his big brother, Robert, and he approaches sports with an impressive discipline. It's an honor to be able to learn from him. I love going to his games and watching him play and give it his all. I am definitely that dad who is screaming on the sidelines as loudly as I can,

probably embarrassing the hell out of him.

I remember when Bear was two years old and he and Terry's niece, Jada, played together every day. Bear was born the day before she was, so they grew up together. One day when we were at Terry's house, the kids were running around the front yard playing.

We both noticed Bear stop in his tracks and hold perfectly still. He looked down and was staring at his shadow on the ground. Terry and I knew what was coming, but we just watched and let it play out. Bear kept staring at the ground and trying to back up slowly and get away from his shadow, but every time the shadow moved with him, he got more and more scared.

Before we knew it, Bear was running around in circles all over the yard, screaming his head off because this dang shadow was chasing him. We laughed so hard, and it brought back a memory of when my brother, Emery, had told me a similar story about myself when I was Bear's age. It was moments like this that I really cherish. All those memories I have watching him grow are really special, and I couldn't have asked for better.

I know this life hasn't been easy on him either. The things he's gone through, some of the chaos he's seen, not having me there when I was locked up, and being seen in the media as the son of the mug shot guy. It's gotta be hard on him. There were times

when he felt like certain people only wanted to hang out with him because he was my son. It's a weird dynamic. Sometimes people treat you differently because they look down on you and sometimes people treat you differently because they look up to you. I think most people just want to be treated like a person. I'm not better than. I'm not less than. I'm just me.

That's one of the things I love about Bear. He's just him.

Jayden was our miracle baby. He was conceived at the height of my addiction, but he and Bear are the reasons I got clean and why I stay clean. They are my driving force.

Preparing for Jayden to come into this world was a whole other experience. The amount of preparation that went into his baby room was extensive. Chloe and I wanted everything to be perfect for him. And the pregnancy with Chloe was just incredible.

Jayden was born in the hospital in Monte-Carlo in 2018.

I started smoking cigarettes when I was really young. I used to smoke a pack a day, but the night Jayden was born, I smoked my last cigarette and haven't had one since.

The hospital there was different from what we're used to in the States. Whereas my mom was allowed to be in the room during Bear's birth, for Jayden, only one person was allowed in the room. So the whole family came in and spent time with us,

then once Chloe went into hard labor, they had to clear out.

It was just Chloe and me when Jayden came into the world. I cried so hard when he was born. For some reason I didn't cry when Bear was born. Maybe it was shock or a little bit of fear because Bear was my first child, but I felt like I held back my emotions during that time. However, with Jayden, I wore all my emotions on my sleeve. I held him in my arms, and I remember crying uncontrollably.

When Jayden was born, I was shocked by his similarities to Bear. He looked like an identical little version of Bear. As he's gotten older, he's developed his own unique features, but when I first saw him, it was like I was looking at Bear as a baby.

It was such an amazing experience to have Bear there with us too. I was really happy to have both of these beautiful, perfect, healthy boys in my life. Jayden is my little firecracker. All gas, no breaks. He's so incredibly smart. He just turned five, and he's already learning how to speak French.

One of his favorite things to do is to go to the park and have play dates with his friends. He's quite the wise guy too. He's the kid who is always cracking jokes and being funny.

Chloe has done such an amazing job with Jayden. She knows how difficult it is for me to live across the world, and even though she's got a lot going on in her life, she makes sure to jump on a

call every day so that I can talk to Jayden and hear how his day went.

She's always sending me videos and pictures of Jayden. She doesn't hold any grudges or make me feel bad about not being able to be there more. She continues to be this amazing person and mother. I am so lucky that I don't ever have to worry about my children. I know that they both have mothers who will protect them and love them to the ends of the Earth. I couldn't have asked for better.

I continue to take care of myself and to work on my growth so that I can be the best version of myself, not only for me but also for my sons.

I still do my different therapy sessions, I journal, and I continue to write down my intentions and my goals and then review them so that I can make sure I'm staying on the right path. I understand that this is something that I'll need to continue for the rest of my life. I don't believe that the things I'm dealing will just disappear with the snap of a finger.

Writing down my pains and acknowledging my childhood trauma is all part of the journey I need to take for my healing. I jot down what I want in my life and what I don't want from my life. I observe what I want to change about myself and review whether my habits reflect that desire or not, and I focus on all the incredible

aspects of my life. It's also really important and healing for me to help others.

I've always been able to look at a person and see beauty inside them, and I've always wanted to leave that person looking at themselves the way that I see them. We all have something special within us, and sometimes we just need someone else to point it out and remind us of who and what we truly are. When you get lost in a lifetime of chaos and shit, sometimes it's hard to remember who you are. Sometimes all we need is a little reminder.

CHAPTER 29: SERVITUDE

I know that my purpose is so much bigger than modeling and acting.

I've had my heart broken and steel aimed at my temples for a reason. If I had twenty-four hours in a row, I couldn't manage to tell you all the blessings that have been bestowed upon me.

I have sisters and a brother I can call to reminisce with at any time. They supported me on my journey to get to this place, and they continue to support me today. I have a mother who is the best grandmother in the world.

I have two sons who bring me joy and remind me how beautiful life can be.

I have enduring friendships with the mothers of my sons who provide me love and loyalty that humbles me.

I have a community of friends and supporters who share their time and energy with me.

I am blessed beyond measure, and I know those blessings come with responsibilities.

My opportunities will be used to change the standard of generational wealth in my family. I want to set my sons up so that they can chase their own passions. Their future is what I am

focused on at all times.

My real calling is not an occupation. I wasn't designed by God to be just a handsome face or a criminal poster boy.

I was put on Earth to open doors for people that would have forever been vaulted shut without seeing that someone who looks like them could survive the impossible.

I'm here to inspire and motivate. I'm here to walk through group homes and detention centers and let people know that there is life after scars and beyond chains. I know that the next week, the next day, the next few hours are not promised to me, and I'm devoting myself to using the time I have to transform lives other than mine.

When I'm standing there, sometimes I'm so raw and honest that it makes me cry. I'm always trying to share my message in a way that those I'm speaking to can really understand how serious things can get if you wait too long to turn your life around. I don't want them to go through some of the things I experienced.

I had no idea when I started running the streets that the torture I saw in the group home was kindergarten. The things I've seen in prison are haunting, and I want these kids to understand that they can learn their lessons without spending their early adulthood fighting against accepting the world as it is and themselves as they are.

"You do not want to graduate," I tell them. "You do not want to see that other side."

Now I have so much understanding. I've lived among the richest of the rich, and I've seen the poorest of the poor. I understand any kind of situation that could ever be presented to me, and I want to use that understanding to help others surprise themselves the way that I have.

The things I've seen. The things I've done. The places I've been. The life-or-death situations I've been involved in—they don't seem real.

I've seen every side of the world two times over, and now I'm sharing what I learned so that other people know they can overcome anything.

From the streets, to the prison cells, to the shores of France, to the chalets of Switzerland, I 've had experiences that make it clear to me that as long as I wake up, I have another chance.

You do too.

CHAPTER 30:
TRUTH OVER TRAUMA

I have spent a lifetime wrestling with the concept of separating my truth from my trauma. In my younger years, I didn't have the language or the comprehension to understand that this was the battle I needed to conquer. Even in the face of what some have labeled a tough hand dealt to me, I have come to realize that the ultimate battle I was fighting was to distinguish between the two. It took time, reflection, and growth, but now, as an adult, I recognize that this distinction is the thread that weaves together my story and my life, which is now labeled my redemption story, especially when the triggers from my traumas threaten to take me down.

Throughout my journey, there have been moments when self-doubt, anxiety, and depression have consumed me. It is through reflection that I recognized these were the times when I failed to distinguish the truth from the residue of my past. I had to learn that I am not my father's aggression or my mother's past struggles with addiction. I am not the things I have done or the choices I have made, most of the time, in the name of survival. I am not defined by the labels or the judgments thrown my way, telling me that I'm not good enough. And neither are you.

But as I continue on my journey of redemption, I've come to realize that this process of unpacking is what we all have in common. It's not just my struggle; it's a universal battle. This understanding has become the source of my daily wins. The daily deposits of laughter and joy and of finding motivation are where I put my focus. I don't allow this log to continue to build. I don't allow it to keep score or accumulate. It's the mirror-talk question I ask myself every day: "Today, was I able to separate my truth from my trauma?" That, to me, is my special power.

It's also the realization that everyone I've encountered along my path shares things in common. Undoubtedly, shadows will always exist, but it's in that darkness that we also find the light. Isn't that the battle we all strive to win each day?

This shared journey of separating truth from trauma extends beyond me. It's the win of my mother, who battled her own demons and emerged stronger. It's the triumph of my brother and sisters, who found their own paths to healing and success. And it's the victory of all the people I have encountered along the way.

It was in the rich landscapes of Monaco, where money wasn't the obstacle but vices and traumas took different shapes and forms, that I discovered a common thread. The impact of our journeys, no matter the specifics, demand unpacking and healing. My story of becoming a model citizen was not only about

learning but also about unlearning. And this process, I've come to understand, is never-ending.

It's an ongoing effort to shed the layers of trauma and unlearn the negative beliefs that hold us back. It requires deep work, vulnerability, and a commitment to self-discovery. That's where the most fertile grounds are cultivated and where we find either seeds of growth or the threatening weeds of setback. It redefines our identities.

As I reflect on my life, I realize that my struggle with truth and trauma is not only my personal victory; it's a shared one. The wisdom and resilience I've gained are not mine alone—they belong to all those who have crossed my path. We are interconnected, bound by the common need to heal and thrive.

I hope that my story serves as an inspiration to others who have faced their own battles with truth and trauma. It's a reminder that our past does not define us. We possess the power to reclaim our identities, embrace our worth, and embark on a journey of self-acceptance and resilience. It's a continuous process of unearthing our truths, confronting our traumas, and evolving into the best versions of ourselves.

The struggle between truth and trauma is real, but so is our capacity to overcome it. For me, that is my deepest breath and my most worthy accomplishment. It's breaking that generational

curse for my kids. That is my freedom. It's through this transformative process of learning and unlearning that we find redemption and healing and when we ultimately become the people we were meant to be. This battle, the battle to separate truth from trauma, is the core of our healing—a testament to our strength and resilience and to the model citizens we can become.

EPILOGUE

Being at a place in my life where I overcame obstacles and where I'm now exposed to new opportunities, it's safe to say that I've finally started believing in myself. I know there's nothing that I can't do. Now more than ever, I feel unstoppable. When the door into the industry was cracked open, I didn't peek my head through or just put one foot inside. Instead, I kicked that door in, and I'm not going anywhere.

All I needed was for someone to crack that door open for me. That's all most of us need. If there's any lesson that you take away from this book, let it be that. We just need that chance to show them what we're made of. To show them what we can do and how hard we're willing to work to get there.

Today there isn't a single part of this industry that I don't want to go into. Not one part that I don't want to try my hand at. How would I have ever known how much I would love acting unless I got out there and tried it? I had to put the fear and doubt aside and just go for it. And that's my life lesson right there. Fear, doubt—they're debilitating. They're parasites that worm their way inside us and make us weaker versions of who we might be.

Where once I never dreamed, now I have them all the time. I dream of all sorts of things, and I trust that God will always have

his arms around me along the way. I dream of a happy, peaceful life, where I'll continue to help those in need and try to inspire and uplift those around me.

Some dreams are simple, like starting my own production company, where I can make films with all these wonderful creatives in my life. Others present challenges, like writing scripts and directing movies, but that just makes me all the more determined. As of writing this, I'm in the process of working with Max Decker on a short film project. I've always wanted to try my hand at a short film that provides the audience with a beautiful and powerful story that can touch their lives. Now I have that chance, because I dreamed.

I never thought those words would come out of my mouth: "I want to direct a short film."

To be honest, it felt weird when we first discussed it, but like I said, there's nothing I don't want to try.

I dream of making music and sharing my stories through sound.

I dream of one day buying property in the mountains and building a fully self-sustained community where all my loved ones can live. We would each have our own houses, of course. That way I can put up my Do Not Disturb sign when I need a time-out.

And there's so much of the world I still want to see.

I've traveled a lot over the last several years, but the one place I've never been and really want to experience is Africa. I want to see all the diverse landscapes. I want to immerse myself in the different cultures, meet the people who make it so incredible, and be in a place that holds such a rich and complex history. I want to stand on their stunning beaches and be at one with the wildlife. Ugo's family lives in Nigeria, and we're planning to visit there within the next year. I'm very excited.

I want to go to Brazil and Japan.

I'd love to hike to the *Christ the Redeemer* statue in Rio de Janeiro and see the Amazon rainforest. I want to connect and dance to their music. I hear it's one of the most beautiful places on Earth. Japan was home to samurai warriors and shoguns, and I find the culture fascinating. I'd love to go there and walk the streets to soak it all in. I can close my eyes and imagine I'm in Tokyo or that I'm exploring the beaches and caves in Okinawa. Mama Donna is half Okinawan and lived on the island when she was a child. She told me so many times how beautiful the ocean is. She lit a passion inside me. Now I want to go diving and see the mysterious underwater city at the Yonaguni Monument and so much more.

I feel blessed to have seen so much of the world, considering

where my journey started, and I'm incredibly excited to think about all the places I'll someday travel to, because I remember too well what it was like living a life behind locked doors.

Dream.

It keeps us alive.

It makes us whole.

It gives us hope.

Dream, because it allows us to glimpse all the possibilities that are hidden within ourselves.

ACKNOWLEDGEMENTS

God, My kids (Jeremy jr, Jayden, Robert & Elli), Leanna, Mom, Emery, Carmella, Shelby, Momma Donna, Big Elias, Terry, Charles Johnson (Ja Rocc), My team (Kara Sax, Camie Gutierrez, Brittany Fuller), Melissa, Chloe, Jim Jordan, Gisada, Shelby & Momma Donna,Pastor Dempsey, Jake, Ugo, Rosalinda, Dp Demarco

I carry with me in every room and space I enter a fullness that comes from many places - experiences, feelings, opportunities, and emotions, spanning both dark and light times. While emotions in a person like me can fluctuate, the one consistent emotion that says most consistently is my deep gratitude. My gratitude is the most present fixture in my heart. I also carry not only my gratitude but also my love and profound respect for my village. For it was all of you who have stood by my side through different seasons in my life.

In your presence, I've experienced deep discovery, strength, weakness, failure, love, brokenness, virality, growth, humility, and still have found my way to the top. With your support, I have weathered life's storms and found the joy in celebrating its victories. You've been more than just friends; you've been my confidants, my unwavering pillars of support, and the companions who have walked beside me through it all. For all the seasons, I give thanks.

To my children and my heavenly father, God, you are whom I call my "reasons." You are my centering. You are my North Star.

I am eternally thankful for the love, encouragement, and wisdom everyone has generously shared with me. Through your unconditional love, you've allowed me to find balance amidst the sometimes-harsh judgment that the rest of the world can cast. You loved me despite my imperfections, you held me when sometimes I didn't know I needed to be held. You have allowed me to define not only my story but to walk through the gates of redemption with my head held high. You helped define and own that this is MY model citizen story.

With heartfelt appreciation,

Jeremy Meeks